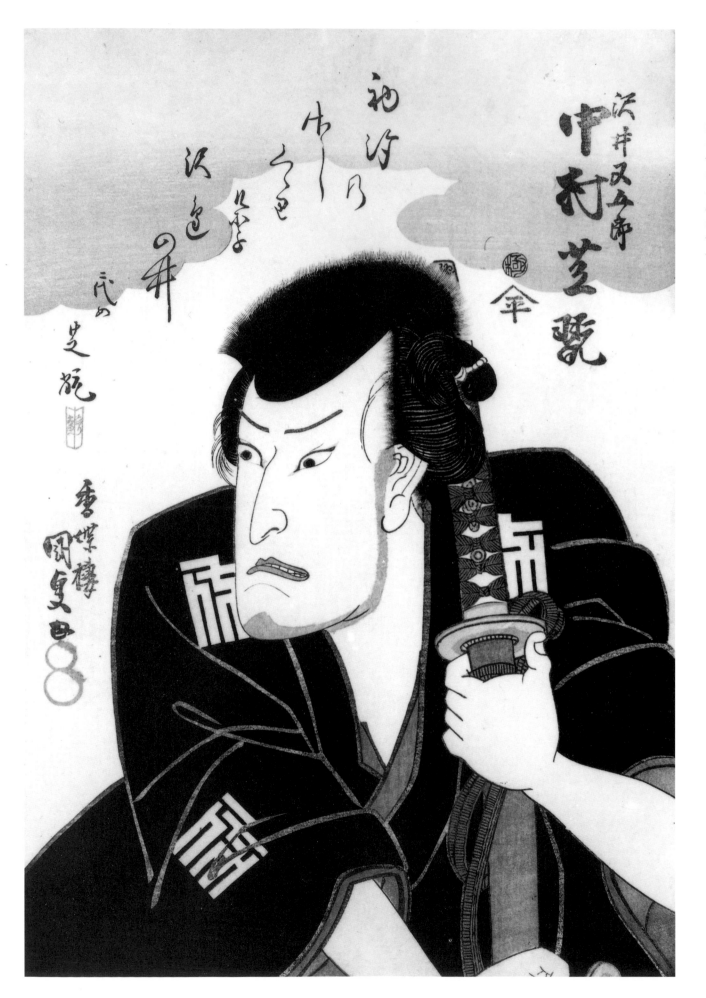

Nakamura Shikan II
(later Utaemon IV) as
the villain Sawai
Matagorô in
*Sunoumayaji sagarano
kikigaki,* one of the
many dramatised
versions of the Igagoye
tale of revenge.
1831
Signed: Kôchôrô
Kunisada-ga with
double-toshidama seal
Private Collection

Mirror
of the Stage

The actor prints of
Kunisada

Ellis Tinios

The University Gallery Leeds

Colophon

Notes

Published by The University Gallery
Leeds, Leeds LS2 9JT, United Kingdom

Published in March 1996 for the
exhibition *Mirror of the Stage* held at the
University Gallery Leeds 24 April - 30
May 1996

*The University Gallery gratefully acknowl-
edges financial support from the Great
Britain Sasakawa Foundation and The
Leeds Philosophical and Literary Society
Ltd. towards the production of this book.*

Design
Robert Schaap, Bergeyk,
The Netherlands

Printer
WorldPrint Limited, Hong Kong

ISBN 1-874331-12X

Front cover
Segawa Kikunojô V in role
See Plate 5

Back cover
**Iwai Kumesaburô II as the lady-in-
waiting Kinugasa**
Centre sheet of a surimono triptych to
commemorate a performance of the
New Year play *Kawaranu hana Genji no
kaomise* at the Ichimura Theare at the
end of 1827
1827/8
Signed: Gototei Kunisada-ga
Robert Schaap, The Netherlands

Kunisada's names

The artist who is the subject of this
study is referred to throughout as
'Kunisada'. In reality he used a number
of names in the course of his long
career. His family name was Sumida but
he never used it in his work, employing
instead two professional names. His
first professional name, **Kunisada,** was
bestowed on him at the beginning of
his career by his teacher Toyokuni.
(Toyokuni granted all of his students
professional names beginning with
'kuni', the second character of his name,
in order to proclaim their relationship
to him.) He signed all of his work
Kunisada from 1807 to 1844. He
assumed his teacher's professional name,
Toyokuni, in 1844 and used it until his
death in 1865. He announced his name
change by signing numerous prints
issued in 1844/45 with the signature
'Kunisada changing to Toyokuni II'
(Kunisada aratame nidai Toyokuni). In
doing so he rejected the legitimacy of the
use of the name by Toyokuni's son-in-law
Toyoshige from the time of Toyokuni's
death in 1825 until Toyoshige's own
death in 1835. (Today Toyoshige is
referred to as Toyokuni II, and Kunisada
is referred to as Toyokuni III.)

In addition to their professional
names, Japanese artists employed
numerous art names *(gô).* Kunisada was
no exception. He signed a number of
his prints just with his professional
name (**Kunisada** before 1844 and
Toyokuni thereafter) but more often,
when signing prints, he preceded his
professional name with one of his art
names. His most frequently encoun-
tered art names are: **Gototei** (used
only with Kunisada), **Kôchôrô** (used
with Kunisada and Toyokuni); and
Ichiyôsai (used only with Toyokuni).
'**Ga**' ('drawn by') was the suffix
Kunisada most often appended to his
signature but in the last decade of his
life he also made frequent use of '**hitsu**'
('from the brush of').

Actors' names

The art of the kabuki theatre was
handed down to successive generations
of actors to refine and develop, and the
continuity of acting traditions was
reflected in their use of the same stage
names. Within a family of actors, the
stage name indicated the rank and
relative skill of the individual using it. In
the course of his career an actor might
progress from one stage name to
another. Thus the name Ichikawa
Danjûrô VII indicates the seventh actor
of the Ichikawa family to bear the stage
name Danjûrô. In 1832, midway
through his career, Ichikawa Danjûrô VII
passed that stage name on to his son
(who performed as Ichikawa Danjûrô
VIII) and himself assumed another stage
name much revered in the Ichikawa
family - Ebizô - to perform as Ichikawa
Ebizô V. Each actor also had a 'shop
name' *(yagô),* which was a nickname
shouted out by fans to encourage him
during a performance. The shop name
linked to the stage name Danjûrô was
Naritaya. Each actor also had a name
with which he signed his poetry *(haigô).*
The poetry name linked to the stage
name Danjûrô was Sanshô.

The size of prints and books

Standard commercial colour wood-
block prints are approximately
38 x 25 cm.
Privately commissioned surimono are
approximately 21 x 18 cm.
Inexpensive illustrated novels *(gôkan)*
measure 18 x 12 cm.
The more expensive books vary, and
may measure up to 25 x 18 cm.

Book titles etc.

In most instances, book titles and the
names of plays and sets of prints have
been translated. The Japanese is often
heavy with puns and double meanings;
the translations offer no more than an
approximation of the original.

Foreword

It is only in recent years that Kunisada's considerable achievement as an artist has begun to be recognised. An exhibition in Tokyo in 1989 was devoted to the actor prints produced before 1844, and in the autumn of 1993 the Japan Society Inc. and the Ukiyo-e Society of America staged a major exhibition in New York of his work in all genres. Kunisada was regarded by his contemporaries as the undisputed master of kabuki actor prints, and an exhibition which does justice to his accomplishments in this genre throughout his long career is long overdue.

In the exhibition at the University Gallery eighty of Kunisada's actor prints, selected from all periods of his long creative life and exhibited together with examples of his book illustrations, offer a fuller presentation. The exhibition also provides a unique opportunity to see particular prints alongside the preparatory drawings from which they were derived. The University Gallery is greatly indebted to the lenders who have made such an exhibition possible, and grateful thanks are extended to the Ashmolean Museum, the British Museum, and the National Museums of Scotland, as well as private collectors in Germany, Holland and England - in particular Professor Gerhard Pulverer, Robert Schaap, Henk and Arendie Herwig, and others who prefer to remain anonymous. Robert Schaap also took on the task of designing this publication, and we have benefited from his guidance and expertise.

The exhibition was the idea of Ellis Tinios, who has played the central part in its curation with an unstinting energy and commitment. He has also written this book, and his deep attachment to the subject will, I am sure, be communicated to many for whom it will be an introduction to a fascinating artist working in a compelling genre.

Hilary Diaper
Keeper of the University Art Collections and Gallery
The University of Leeds

Introduction

This book has been written as an introduction to nineteenth-century Japanese colour woodblock actor prints and to the achievements of the artist Kunisada in that field. It is divided into three sections. In the first I examine four topics: the social and cultural milieu that gave rise to the production of prints as items of mass consumption; the aesthetic of the actor print; the economics of print production (including consideration of the numbers issued, the prices at which they were sold and their rates of survival); and the process by which prints were produced. The second section consists of sixteen colour plates with commentaries. In the final section I survey Kunisada's career.

Kunisada's career as a commercial artist spanned nearly sixty years and his output was enormous. Estimates of the number of prints issued bearing his signature run as high as twenty thousand designs. In selecting the illustrations for a book of this size, I have not attempted to include examples of every category of his actor prints. Preference has been given to those formats that lend themselves best to reduction to the limits of a book page.

I wish to thank Tim Clark, Hilary Diaper, Henk Herwig, Oliver Impey, Henri Kerlen, Eiko Ono, Gerhard Pulverer, Robert Schaap, Tohru Sekigawa, Martin Spiers and Jane Wilkinson for their assistance at various stages in the preparation of this book.

Ellis Tinios
The University of Leeds
September 1995

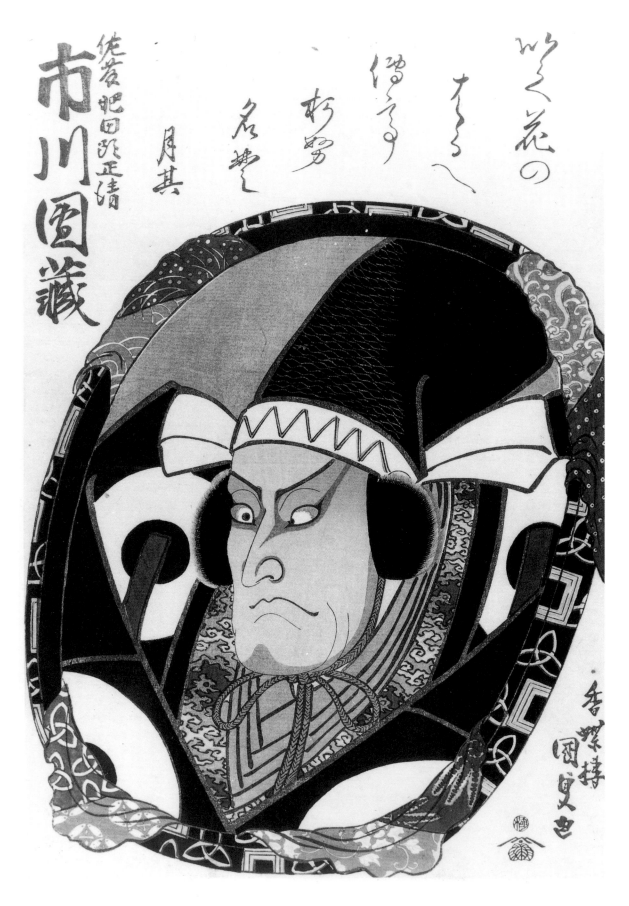

1. Ichikawa Danzô V as the heroic Satô Hidanokami Masakiyo in *Hachijin shugo no honshô* performed at the Ichimura Theatre in 1833. From an untitled set of actor portraits reflected in mirrors. 1833. Private Collection.

The cultural context

Utagawa Kunisada (1786-1865) was the most prolific and successful of all Japanese print designers. His creative life unfolded within the ukiyo or 'floating world', which embodied the liveliest and most sophisticated manifestations of the popular culture of the Edo period (1603-1868). The term ukiyo had entered the Japanese language centuries earlier as a Buddhist expression that denoted this transient world of sorrows from which release was to be sought. In the course of the seventeenth century it was recoined to apply to the new world of earthly pleasures that had sprung up in the towns of Japan, which were prospering as never before in the peace imposed upon the country by the military dictatorship of the Tokugawa clan. The ukiyo was transformed from that which one sought to escape into something that was avidly pursued by high and low alike. It consisted of 'fugitive pleasures, of theatres and restaurants, wrestling-booths and houses of assignation, with their permanent population of actors, dancers, singers, story-tellers, jesters, courtesans, bath-girls and itinerant purveyors.'[1] The colour, noise and excitement of this world were vividly depicted in the popular art and literature of the period.

Edo (present-day Tokyo) was the seat of the Tokugawa shogun and rapidly became the most important city in the country. The members of the shogun's swollen bureaucracy, together with his captive military aristocracy and their families and retainers, comprised one half of the city's population of one million; the other half was made up of the merchant and artisan townsmen who served their needs. These townsmen were 'restricted by the sword-carrying government ... from doing much else than make money or love,'[2] and it was among them that the brash, exciting culture of the ukiyo took root and flourished. They patronised the houses of assignation, the restaurants and teahouses, they attended the kabuki theatres, and they bought in prodigious numbers the inexpensive books and prints that recorded every detail of the ukiyo. The merchants and artisans and their households may have shaped and sustained the ukiyo, but their social betters, the samurai, were not immune to its attractions. The shogun's officials despaired of the deleterious effect of the ukiyo on the morals of high and low alike, but they could not suppress it. They could only harass and restrict it.

Inseparable from the growth of the ukiyo were the related phenomena of increasing literacy among the townsmen and the development of printing. Before 1600 printing had been restricted almost entirely to the production of Buddhist texts and images. With the growth of literacy in the Edo period, commercial printers appeared who eagerly cultivated a mass market for inexpensive secular books.[3] Much of the popular

literature they published for this new market was rooted in the ukiyo; it served both to define and propagate its values. The technology employed - woodblock printing - could reproduce images as easily as texts. As a result, illustrations fully integrated into the text came to form an important part of many of these books. By the 1680s the artists engaged in popular book illustration had developed an elegant, fluid style that was well suited to the woodblock print medium. Publishers soon realised that there was also a market for free-standing illustrations, and by the early eighteenth century they were regularly offering unbound prints for sale. The earliest were printed in black ink only from a single block with optional colour added by hand. Once the means of achieving a consistently accurate registration of colours was perfected in the 1720s, printing from three blocks in black, pink and green became the norm.[4] In the mid-1760s, polychrome printing was mastered and quickly applied both to book illustrations and to prints. The artists who provided the designs for these popular book illustrations and prints belonged to the ukiyo-e school. (The literal meaning of ukiyo-e is 'pictures of the floating world'.) Throughout the Edo period, the subjects most often depicted by these ukiyo-e artists were courtesans and kabuki actors. Although the practitioners of both these professions were classified by the state as legal outcasts, between them they embodied the essence of the ukiyo.

Socially, ukiyo-e artists were ranked as artisans, not artists. Officially, their prints and paintings were regarded as 'vulgar pictures' (zukuga) in contrast to the 'true pictures' (hon-e) of more elevated subjects produced by the artists of the state-sponsored Tosa and Kanô schools. The divide between these two categories of art was further emphasised by regulations forbidding ukiyo-e artists from studying with Tosa or Kanô masters, and the distinction between the 'painting fees' (garyô) received by the latter and the 'payment for their labour' (tema-chin) received by ukiyo-e artists.[5]

The development of woodblock printing ran parallel to and was intimately connected with the development of the kabuki theatre, the most vigorous of all manifestations of the ukiyo. The origins of kabuki can be traced to the early seventeenth century, to summer performances on the dry bed of the Kamo River that runs through the imperial city, Kyoto. These performances, by a troupe of women led by the female shrine dancer Okuni, were bawdy and often unruly affairs, and in 1629 the government responded by banning women from the stage. New troupes, made up entirely of boys and young men, quickly emerged to take their place. Further legislation enacted in 1652 removed

1. G. B. Sansom, *Japan: a Short Cultural History*. London 1932, revised edition 1952, p. 477.

2. Earl Miner et al, *The Princeton Companion to Classical Japanese Literature*. Princeton 1985, p. 79. For a breakdown of the population of Edo in the early nineteenth century see Henry D. Smith II, 'The Floating World in Its Edo Locale, 1750-1850' in *The Floating World Revisited*, edited by Donald Jenkins. Portland, Oregon 1993, esp. pp. 28-32.

3. See Henry D. Smith II, 'The History of the Book in Edo and Paris' in *Edo & Paris: Urban Life and the State in the Early Modern Era*, edited by James L. McClain, John M. Merriman, and Ugawa Kaoru. London 1994, esp. pp. 332 ff.

4. For a description of the way in which accurate registration was achieved see below, p. 13.

5. See Nobuo Tsuji, 'The International Evaluation of Utamaro's Art' in *The Passionate Art of Utamaro*, edited by Shûgô Asano and Timothy Clark. London 1995, p. 20.

these youths from the stage, for they too were 'more prostitutes than actors.' Therafter, female roles had to be taken by mature men who were forced to place greater reliance 'on acting resources than on physical attraction to put across a role.' Out of this necessity developed the art of the onnagata (female impersonator), which remains one of the glories of the kabuki stage to the present day (fig. 2). Government interference and regulation had the effect of transforming what had begun as vulgar performances by male and female prostitutes into a vigorous popular art form.[6]

Plays fell into two broad categories: historical tales and contemporary domestic dramas. By Kunisada's time kabuki had come to be characterised by spectacular scenic effects, sensationalism and overt eroticism, which some critics of the day decried as evidence of a general decline in standards.[7] Close government supervision nevertheless assured that all plays upheld the officially sanctioned moral code and did not comment on any member of the Tokugawa house, past or present, or on current affairs. Plays were therefore devoid of overt social criticism. In them the individual was shown trapped between a merciless moral code (which always triumphed) and his or her personal feelings.

Government disapproval and official restrictions could not prevent the kabuki theatre from growing into what may best be described as a popular obsession. In the eighteenth and nineteenth centuries people of all classes attended plays and were passionate in their support of their favourite actors. They followed kabuki with an intensity that resembles a combination of the loyalty of football supporters and the devotion of soap-opera fans. In day-to-day conversation the general public drew upon examples from the stage to illustrate points of personal and public morality. Actors themselves were taken as arbiters of fashion. Some fans went so far as to model their voices and demeanour on their favourite actors. Kabuki actors - denigrated by officials as 'riverbed beggars', declared legal outcasts and subjected to formal restrictions and close regulation - had nevertheless become the models and heroes of the people. With kabuki looming so large in the popular imagination the impetus behind the demand for inexpensive prints of favourite actors becomes clear. Men, women and children wanted to surround themselves with images of their favourite actors in their current roles. Were it not for the public's insatiable appetite for actor prints, it is unlikely that the level of demand necessary to sustain and develop the colour woodblock print industry would have existed.

In the prints issued in the last three decades of the eighteenth century, the actors' portraits, whether in half-length or full-length format, were devoid of any textual information apart from the artist's signature. Only occasionally might a series title be included. Actors' names and their roles were never given, since the conventions by which individual actors were depicted were firmly established and widely known, and costume and pose allowed the aficionado to identify the role and play. These prints were intended for an audience of Edo-

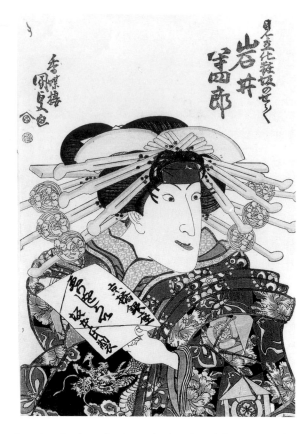

2. Iwai Hanshirô V as the courtesan Kewaizaka no Shôshô, in an imagined casting (mitate) unrelated to a particular performance. The actor is shown holding a packet of face powder by a leading Edo cosmetics manufacturer, c. 1831 Private Collection.

based enthusiasts. In the early decades of the nineteenth century, there was an 'astonishing spread in the popularity of kabuki ... from the great cities to smaller towns and even into the country,'[8] which greatly expanded the potential market for actor prints. Publishers and print artists, realising that this market included many who would not have known the great stars by sight, provided the information necessary to guarantee the accessibility of their product to the greatest numbers. Thus from about 1805 it became the norm to include actors' names and the roles in which they were depicted on all commercial prints. Consequently, woodblock actor prints circulated more widely than ever before throughout Japan.

Despite the repeated efforts of moralising ministers of state to propagate more seemly values among the common people, the latter persisted in regarding actors and courtesans as models of fashion and deportment, and often even elevated them to the status of popular heroes. They were eager to acquire bright, inexpensive images of their favourites to paste onto the walls of their homes, or to collect in albums. A vigorous industry developed in response to the seemingly insatiable demand they created for those images. By the time of Kunisada's birth in 1786 the ukiyo had been flourishing for well over a century. Its legal limits had long since been established, its artistic conventions had been defined and developed by generations of artists, and its commercial potential successfully exploited. Kunisada was to thrive in the ukiyo, internalising its artistic conventions, responding unerringly to the demands of its market, and partaking of its multi-faceted pleasures.

6. Donald H. Shively, 'The Social Environment of Tokugawa Kabuki' in James R. Brandon et al, Studies in Kabuki: Its Acting, Music and Historical Context. Honolulu 1978, pp. 9-10.

7. Cited in Donald Keene, World Within Walls: Japanese Literature of the Pre-modern Era, 1600-1867. Tokyo 1978. p. 458.

8. Matsukatsu Gunji, Kabuki. Tokyo 1984, p. 31.

The aesthetic of actor prints

The kabuki theatre not only determined the subject matter of actor prints, it also helped shape their aesthetic. The three most obvious features of actor prints are: the starkly stylised yet highly individualised rendering of actors' faces; the depiction of a limited range of intense expressions on those faces; and the presentation of each figure in its own space, without overlap or intrusion into that space by any other figure. Each of these features reflects important conventions of kabuki.

Edo-period theatregoers willingly accepted a high degree of stylisation in performance. They relished the actors' mastery of the conventions of the stage and applauded their creativity within those conventions. They also appreciated their innovative use of the effects possible on the kabuki stage. In prints a comparable relationship existed between the audience and the artist. An artist's success depended upon his public's appreciation of his mastery of established representational conventions, his creativity within those conventions, and his ability to exploit the techniques of woodblock printing.

The artist's first priority in all actor prints was the creation of an immediately recognisable portrait. This was achieved through reliance upon 'true likenesses' (nigao), which offered precise distillations of the distinguishing features of each actor. The resulting portraits were distinctive and immediately identifiable.

A significant change had occurred in the way actors were depicted in prints in the course of the eighteenth century. In the earliest prints, roles were identifiable through pose and costume but little effort was made to depict the individual characteristics of the actors. It was not until the 1760s that Shunshô (1726-92) introduced 'true likenesses' into actor prints. He was praised by his contemporaries for portraying, within the conventions of his school, the actual facial features of actors. He achieved this by relying upon a few keenly observed features to distinguish each actor. His method proved very effective in producing readily identifiable images of actors, no matter which artist of his school employed it. Thereafter, reliance upon a system of standardised likenesses became the norm in the actor prints designed by artists of all schools.

The way in which 'true likenesses' were constructed and used is revealed in a small book illustrated by Toyokuni (1769-1825) and issued in 1817, which is entitled *Quick Instruction in the Drawing of Actor Likenesses (Yakusha nigao haya-geiko)*. The book was intended for the amateur who wished to learn to draw his favourite actors in the appropriate style; its contents reflected the instructional material that students would have encountered while training in Toyokuni's studio. In the book Toyokuni set out the order in which the features of the face should be drawn. Start with the nose, 'the centre of the face'. Then draw the mouth, the eyes and the eyebrows in that order and finally the outline of the face itself. Toyokuni stressed that the conventions of kabuki acting had to be understood when placing the pupils in the eyes and drawing the eyebrows. As regards the latter, he explained that 'The eyebrows are determined by the nature of the eyes. When an actor stares, worries or laughs, the eyebrows should be drawn according to the eyes.' Indeed, in fine actor portraits not only are the eyes immediately arresting but the eyebrows are subtly placed and expressively modulated. Toyokuni followed these instructions with 'true likenesses' of twenty leading actors (fig. 3). These highly stylised representations provided an effective means through which to convey a sense of the stage presence of individual actors.[1]

The bold stylisation of features that formed the basis of 'true likenesses' faithfully reflected the powerful simplification of facial features achieved by the make-up employed on the kabuki stage, which produces a result that has been described as 'a compromise between the human face and the mask.' The use of a dead white make-up base makes it possible to heighten the prominence of the nose, the mouth and above all the

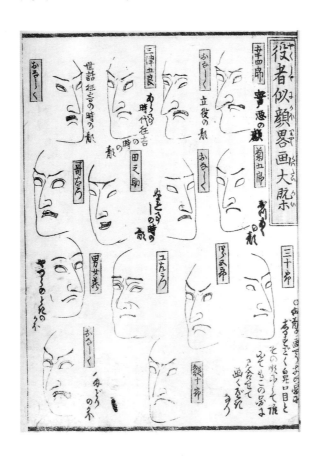

3. A page of 'true likenesses' (nigao) from Toyokuni's manual *Quick Instruction in the Drawing of Actor Likenesses (Yakusha nigao haya-geiko).* 1817. Trustees of the British Museum.

1. For a more detailed account of this book, see Ellis Tinios, 'How to Draw Actor Portraits: An Introduction to Toyokuni's *Yakusha nigao haya-geiko'* in *Andon* 32 (1989), pp. 168-174.

eyes. This might be done, according to the role, with touches of colour and fine lines around the mouth and eyes, or with bold red or blue lines drawn across the face. The mask-like quality of the actors' faces is further enhanced in performance by the avoidance of facial reactions except at the most significant moments of a scene. At those moments, the actors adopt the highly stylised stances and facial expressions appropriate to their emotional states, which might include tight grimaces and crossed eyes. These expressions stand in 'high relief against the ground of facial immobility' that otherwise prevails.[2] The print artist depicted those significant moments. The powerful, mask-like faces encountered in prints, with their sharply stylised renderings of nose, eyes, eyebrows and mouth, offer a close approximation of the way in which actors' faces were, and still are, read in the kabuki theatre.

Actors' faces were rarely shown in profile or full-faced in prints because of the difficulty in presenting their standardised features in a readable way from those angles. The only actors occasionally shown in profile were those noted for prominent noses. Full-face rendering was rarely attempted, and then nearly always when the role in which the actor was depicted called for the painting of bands of colour across the face. The overwhelming preference was for the three-quarter portrait. It was only in this format that the line of the nose, the shape and placement of eyes and mouth, and the outline of forehead, eye-socket, cheek and chin - an essential feature of all 'true likenesses' - could be depicted clearly.

Neither the outline of the actor's face nor his figure were obscured in print designs by props, costumes or other actors. This unobstructed rendering of the face and figure reflected the preference on the kabuki stage for the visual isolation of the leading characters. As described by Earle Ernst, 'the characteristic movement of the actor is away from the other elements of the production and toward concentration of theatrical expressiveness within his own figure.'[3] It is this concentration within the figure of the actor that the artist sought to replicate in his print designs. Even when leading characters are in intense interaction with one another, each always occupies his own unobstructed stage space. For some roles the dynamism of the character is indicated by increasing the volume of his costume. The imposing bulk and strong colours of these costumes further emphasise the isolation of the character and heighten the strength of his stage presence. In response to these conventions artists treated each figure as a free-standing element, paying careful attention to its bulk and outline. Diptychs and triptychs, which typically have just one figure centred on each relatively broad sheet, may sometimes fail as coherent large-scale compositions, but they faithfully reflect the placement of actors and the treatment of space on the kabuki stage. Thus the absence of complex, three-dimensional compositions in actor prints does not indicate a lack of imagination or skill on the part of the

artists, but rather their fidelity to the spatial conventions of the kabuki stage.

At the most significant moments of a scene, when highly stylised expression burst through the actor's mask of facial immobility, he also adopted a prescribed pose. The pose and expression together are referred to as *mie*. In a *mie* the actor literally screws himself up into a pose of extreme dramatic tension, with limbs rigid, fists clenched, and the face drawn into a powerful expression. The greater the skill of the actor, the longer he takes to assume the full *mie*. Then the entire stage scene freezes in what has aptly been described as 'a visual exclamation point'.[4] These moments should be seen in the wider context of the way in which kabuki drama moves toward 'static scenes of anguish' in which 'the individual is caught, immobile, at the point where social duty and human feelings erect their opposing fields of force.' These scenes form the 'essential substance of the plays'.[5] It was precisely these scenes that the theatregoer awaited most eagerly, precisely these scenes the print designer set out to capture.

Within the relatively narrow repertoire of compositional devices available to him, the artist added interest and variety to his designs by exploiting the wide range of colours, patterns, textures and finishes possible in the woodblock print medium. Among the effects available were matt and gloss finishes, the shading of colours one into another, blind-printing of textures and patterns, over-printing of colours, the application of mica, and the use of metallic pigment. Just as opulent costumes contributed to the thrill of kabuki performances, so too, the meticulous depiction of those costumes formed an essential feature of actor prints. Actors on stage preferred a hunched or stooped posture that raised the line of the shoulders well above the ears, the better to set off their faces against their richly patterned costumes. Artists reflected this convention in their prints for the same reason. In particularly effective print designs the images and/or patterns incorporated into the costumes serve to reflect and enhance the emotions being expressed by the actors.

Just as the actor created a powerful theatrical reality through his mastery of the conventions of kabuki, so too the designer of actor prints created powerful theatrical images through the exploitation of a narrow range of compositional devices and highly stylised modes of depiction. In both art forms stylisation was regarded as more expressive than naturalism. Poses, facial expressions, costumes and the spacing of figures were all predetermined. Within those limits actor and artist displayed their creativity and originality.

2. Earle Ernst, *The Kabuki Theatre*. Oxford 1956, reprinted Honolulu 1974, pp. 195-6.

3. Ibid., p. 198.

4. James R. Brandon, 'Form in Kabuki Acting', in Brandon et al, *Studies in Kabuki*, p. 84.

5. Ernst, *Kabuki Theatre*. p. 237.

The cost of prints, size of print runs and the survival of prints

Japanese colour woodblock prints were designed in far greater numbers, published in far larger editions, aimed at a much wider audience and considered more ephemeral than the serious graphic arts of the West. They were never intended to be 'high art'; they were unabashedly popular and utterly commercial in intent, thriving on novelty, brightness, and impermanence.

Actor prints were inexpensive and readily accessible. The price of a single standard size, commercially issued print remained constant at about twenty *mon* throughout Kunisada's career.[1] In comparative terms, a print cost about as much as a haircut, ten pairs of straw sandals, or an inexpensive meal such as a bowl of buckwheat noodles, and half as much as the cheapest admission to a kabuki theatre.[2] At these prices a publisher had to produce and sell large runs of prints in order to meet his initial capital outlay and operating costs, and still show a profit. His expenses included the cost of buying an original design and materials (wood for the blocks, paper and pigments). He then had to pay the cutter of the blocks and the printer who actually made the print. Finally he had to cover the expense of distributing and selling the print. For many years it was said that Japanese woodblock prints were issued in 'editions' of two hundred, a figure that encouraged Western collectors in the belief that they were acquiring 'limited edition' graphic art. Such a low figure makes the economics of the industry look very suspect. Notes in a printer/ publisher's diary indicate that in Kunisada's lifetime prints were produced in multiples of a thousand, while a late nineteenth-century biography of Kunisada records an observation that it was not unusual to sell three or four thousand copies of an actor print.[3] These figures are corroborated by the fact that many thousands of pulls can be taken from a block before it begins to show signs of wear and that an experienced printer could take three thousand pulls from a keyblock or seven to eight hundred pulls from a colour block in a day.[4] It seems likely therefore that no fewer than one thousand impressions were produced of any commercial print design. The total output from Edo's dozens of publishers reached millions of individual sheets. The market for the prints was there, not just in Edo, but throughout Japan. From the mid-eighteenth century prints were known as one of the famous products of Edo and found their way to the most distant corners of the country.

The publication of some commercial prints was sponsored by firms in return for conspicuous 'product placement'. In the late 1820s and 1830s, for example, packets of a face powder manufactured by a Mr Sakamoto at Kyôbashi, Ginza, appear in prints in the hands of both actors and beauties (fig. 2). Other prints carry the marginal inscription 'Sponsored by Bigenkô',

Bigenkô being the name of another of Sakamoto's products. There is evidence to suggest that individuals or firms may also have sponsored prints without receiving credit for having done so on the prints themselves. A Mr Mitani, head of a long-established Edo firm trading in iron and copper, appears to have sponsored the publication of the massive retrospective set of 'large-head' actor portraits that occupied Kunisada in the last years of his life (plate 16).[5] It is likely that there were also occasions when actors, theatre managers and teahouse owners subsidised the production of commercial prints. Because of the scrappiness of the available evidence it is not possible to determine the extent or importance of this sponsorship.

In contrast to the commercially issued prints discussed thus far, there was a category of privately commissioned prints known as surimono (literally 'printed things'). Ukiyo-e surimono were smaller than standard commercial prints and proportioned differently.[6] They also differed from the commercial issues in their extraordinary opulence. The finest paper, the costliest pigments and most meticulous printing techniques were employed in their production. Lavish use of blind printing, mica and metallic pigments are characteristic features of these prints. Individuals commissioned surimono as private greeting cards, or as mementos of particular events, for their friends or clients or, in the case of actors, for their sponsors and

4. Ichikawa Danjûrô VII looking out of a frame at his seven year old son Ichikawa Shinnosuke II (later Danjûrô VIII) as the child priest Namazu Bôzu. 1830. Surimono. Gerhard Pulverer, Cologne.

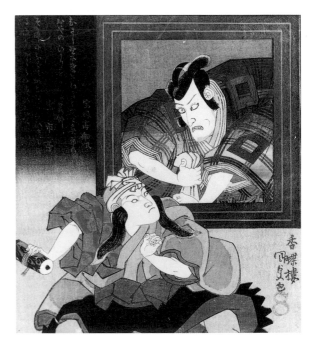

1. Santô Kyôden noted in 1805 that the price of a standard print was 20 *mon*. The government reforms of 1842 sought to limit the price of prints to 16 *mon*, but according to a tradesman's diary, in 1848 triptychs were again selling for between 60 and 72 *mon*. Tatsurô Akai, 'The Common People and Painting' in *Tokugawa Japan: the Social and Economic Antecedents of Modern Japan*, edited by Chie Nakane and Shinzaburô Ôshi, translation edited by Conrad Totman. Tokyo 1990, pp. 184 and 185, and Sarah E. Thompson and H. D. Harootunian, *Undercurrents in the Floating World: Censorship and Japanese Prints*. New York 1991, p. 79.

2. See Akai, 'Common People', pp. 184-5, and Roger S. Keyes and Keiko Mizushima, *The Theatrical World of Osaka Prints*. Philadelphia 1973, p. 33.

3. See Akai, 'Common People' pp. 185-6, and Iijima Kyoshin, *Ukiyo-e shi Utagawa retsuden*, edited by Tamabayashi Seirô. Tokyo 1941, reprinted 1993, p. 137.

4. See Matthi Forrer, *Eirakuya Tôshirô, Publisher at Nagoya*. Amsterdam 1985, p. 76, and 'Tokuno's Description of Japanese Print Making' edited by Peter Morse in *Essays on Japanese Art Presented to Jack Hillier*, edited by Matthi Forrer. London 1982, pp. 131-132.

5. See Ôkubo Jun'ichi, 'Sansei Toyokuni bannen no shokan to yakusha ôkubi-e' ['Letters and Portraits of Kabuki Actors by Toyokuni III in His Later Years'] in *Museum: Art Magazine edited by the Tokyo National Museum*, No. 478 (January 1991), pp. 25-39.

6. The size of most ukiyo-e surimono is approximately 21 × 18 cm.; the size of commercially issued ukiyo-e prints is approximately 38 × 25 cm.

fans. The latter might themselves commission surimono to extol the virtues of their favourite actor. Poems appropriate to the occasion formed an integral part of the surimono, with much play between the verse and the image. Since surimono were not offered for sale, they did not require a censor's seal or publisher's mark. When most in vogue ukiyo-e surimono must have formed an important part of many publishers' trade.

Some commercial actor prints were issued in two editions. In these instances most of the run was printed to the usual standard, but a small number of impressions were produced at a higher standard that approached the quality of surimono, with better paper and more expensive pigments. Also found in such deluxe editions are multiple printings of the same colour to increase its depth, use of metallic pigments, burnishing of certain printed areas, more extravagant use of blind printing, and the application of mica.[7] Nothing is known about the circumstances surrounding the production of special editions. They would certainly have cost more to produce, and it is likely that they were the result of specific commissions from fan clubs, actors or theatre managements. Because of the fragmentary nature of the evidence, it is impossible to determine the frequency with which deluxe editions were produced or to judge their importance in the print trade.

Edo publishers belonged to one of two guilds: the 'serious book' (shomotsu) guild or the 'light book' (jihon) guild. The publishers of prints were members of the 'light book' guild and might produce illustrated books in addition to prints. The books they published included guides to the current kabuki scene and the leading beauties of the brothels of the Yoshiwara, inexpensive illustrated serial novels, and more costly volumes of sumptuously produced erotica. Illustrations of Edo publishers' shops show books set out for sale side by side with prints.

The production of fan prints, which were very popular accessories in the eighteenth and nineteenth centuries, was not governed by the guild of 'light book' publishers. Fan print publishers belonged to their own guild and observed their own rules and regulations. The same artists provided designs for both groups of publishers; the images appearing on prints and on printed fans were identical.

All woodblock prints were ephemera, but the survival rates of commercial prints, fan prints and surimono differ widely. A very small proportion of fan prints survive because of the wear and tear of the use for which they were intended. In contrast, a much higher proportion of surimono appear to have survived. Their smaller size, opulence and fine detail demanded close examination to be fully appreciated, while the occasions on which they were commissioned and distributed are likely to have imbued them with a special significance for the recipients. As a result, surimono tended to be treated with particular care. While commercial prints did not fare as badly as fan prints, they were not treated as carefully as surimono. Once a commercially issued print was purchased - and they were purchased by children as well as adults, women as well as men - it was likely to be

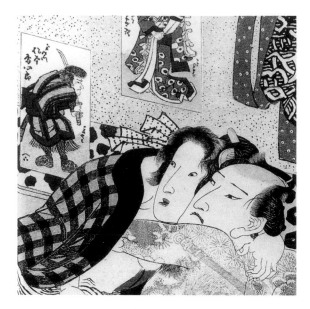

pasted onto a wall or screen (fig. 5). Its colours would quickly fade, its surfaces would be rubbed and become grimy. In other words, it would soon be ruined. It was a simple matter to replace it with a bright, fresh new print of a favourite actor in his latest stage hit or a courtesan decked out in the latest fashions. Commercial prints that were not stuck onto walls or screens might be kept in boxes or baskets to be viewed from time to time by adults and played with by children. These prints were easily soiled, stained and creased, and some were defaced with childish doodles. Only a small proportion of commercial prints was ever cared for in any way. Care usually meant their being assembled into albums. These could be of two kinds. In the one the prints were glued back to back, bound together and trimmed to produce a book-like album. In the other they were attached vertical edge to vertical edge and folded to form a concertina-album. Most surviving well-preserved prints come from such albums, but as a result they are likely to be trimmed or to have strong centre folds. Very few survived unscathed as loose sheets, preserved through the years in the boxes and portfolios of dedicated collectors. The number of surviving prints in all categories was reduced further by the fires that so often destroyed large parts of Edo/Tokyo and other Japanese cities. A recent study reports nine great fires within a twenty-eight year period in the early nineteenth century. 'On average, there was a major conflagration once every six years [in Edo]. Moreover, even apart from the so-called great fires, there were many years when a series of smaller fires did damage just as extensive.'[8] In this century, Tokyo suffered two fires far larger in scale and destructiveness than any experienced in the Edo period. The first followed the great Kantô earthquake of 1923 and the second was the result of the fire bombing raid of March 1945.[9] Thus although at least a thousand copies of a particular commercial print would have been produced, most actor prints survive in only a handful of impressions and of those only one or two are likely to be in pristine condition.

5. Two actor prints pasted onto a partition before which a couple is making love. Detail from an illustration in *Singing of Love in the Four Seasons (Shiki no nagame)*, a sumptuously produced four-volume erotic work, c. 1830. Gerhard Pulverer, Cologne.

7. For colour illustrations of the standard and deluxe editions of an actor print see Ellis Tinios, 'Kunisada and the Last Flowering of *Ukiyo-e* Prints' in *Print Quarterly*, Vol. VIII, No. 4 (December 1991), pp. 350-351.

8. William W. Kelly, 'Incendiary Actions: Fires and Firefighting in the Shogun's Capital and the People's City' in *Edo & Paris*, p. 313.

9. These fires also destroyed the diaries, correspondence and account books of artists, publishers and collectors as well as artists' model books and reference collections, paintings, printing blocks, etc. The loss of so much of this material has deprived the student of print artists, prints and printing of essential information.

The production of woodblock prints

6. Annotated drawing of Bandô Mitsugorô III as a footman (yakko) holding an ornate umbrella as he dances. From a set of designs for prints depicting the actor in a seven-role quick-change dance he performed at the Nakamura Theatre in the ninth month of 1820. Ashmolean Museum, Oxford University.

7. This print is based on the drawing illustrated in figure 6.
© The Trustees of the National Museums of Scotland 1996.

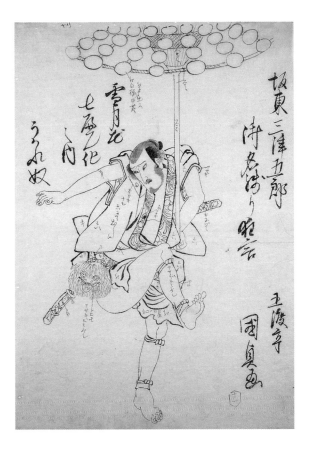 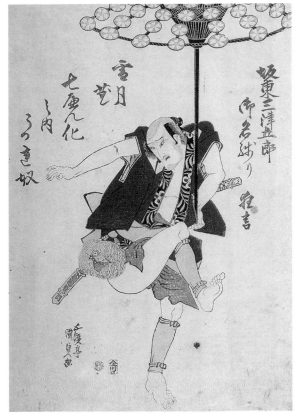

The production of woodblock prints relied upon the interlocking skills of print designers, block cutters and printers, co-ordinated (and financed) by licensed publishers. Although no written accounts of the way in which those artisans worked together survive from the Edo period, there is sufficient evidence - preparatory drawings, printing blocks, the prints themselves and occasional comments in letters and diaries - to permit a reconstruction of the essential stages of the process.[1]

The process began with the publisher's request to an artist for a print design. From preliminary sketches the artist or his assistants worked up a finished drawing with precise instructions written on it indicating the colours and patterns in which the various parts of the design were to be printed (fig. 6). That drawing was then copied, either in the artist's studio or by a professional copyist engaged by the publisher. That copy, which did not carry the printing instructions, was sent to the block-cutter. He pasted it face down on a block of cherry wood, knifed around the lines and gouged out the ground to leave the outline of the design in relief. This was the keyblock. Guides to hold the paper in place in order to ensure the accurate registration of the colours were also cut into the keyblock. These consisted of an 'L' shaped notch at the bottom left corner of the design and a vertical bar along its upper left edge. Sheets were

printed from the finished keyblock. Then, following the instructions on the original drawing, the areas of each colour required by the finished print were indicated on a separate copy of the keyblock print. (It is not clear whether it was standard practice for this marking of the keyblock prints to be done in the artist's studio or in the block-cutter's workshop.) The block-cutter then pasted each marked keyblock print onto a block of wood - one block for each colour - and cut away all but the area to take a given colour on each block. The block-cutter also cut the registration notches that had been printed onto each impression of the keyblock into each colour block. All the blocks then went to the printer.

The printer worked by inking a block with the appropriate colour, aligning a sheet of paper by setting it against the registration marks, laying it face down on the inked colour block, and then applying pressure to the back of the paper by rubbing it with a round pad. A number of sheets would be printed from one block in this way. Once the ink on those sheets had dried, the process would be repeated with another block until all the required colours had been printed onto the sheets. Most nineteenth-century prints were printed off eight to twelve blocks. The exact registration of each colour was ensured by the notches cut into each block, which held the paper in proper alignment for each printing. The printer's own

1. The earliest and fullest surviving accounts of printmaking were written by Kawasaki Kyosen in Osaka in the 1870s and T. Tokuno in Tokyo in 1889. See 'Tokuno's Description of Japanese Print-making' edited by Peter Morse, in *Essays to Hillier*, pp. 125-34, and Kawasaki Kyosen's reminiscence 'How Color Prints are Made', translated in Keyes & Mizushima, *Osaka Prints*, pp. 318-20.

skill was essential to the success of the finished product. He was not only responsible for the careful placement of the paper and smooth printing of each colour, but also had to judge the degree of wiping required on certain blocks to achieve the gradations of colour that so often formed an important element of print designs.

Ukiyo-e artists, particularly those working in the nineteenth century, produced so many designs for so many publishers that it is unlikely, if not impossible, that they could have followed each design through all stages of production. They are likely to have done so only in exceptional circumstances. They could be confident that the public's high expectations as regards the quality of the prints they purchased and the intense competition that existed within the publishing industry would ensure the quality of the finished product. In this world no publisher could survive for long if he offered shoddy prints for sale. The system relied upon an impressive commitment to quality on the part of print designers, block-cutters, printers, publishers and consumers.

Some artists, such as Utamaro (1754-1806), may have enjoyed a close, long-term relationship with one publisher, but this was not the case with any of the major nineteenth-century ukiyo-e artists. They quite freely provided a multiplicity of publishers with designs. The extent of their 'promiscuity' is strikingly illustrated by Kunisada's half-length actor portraits. Between 1812 and 1840 he designed twenty-nine sets of half-length actor portraits; they were issued by nineteen publishers. Of those publishers twelve were responsible for just one set each and only one issued as many as four sets.

When Edo publishers purchased a print design from an artist they purchased all rights to the design as well. The blocks they had cut were their property, not the artist's, and they could sell them to other publishers or reuse them as they saw fit. It was the blocks for the printing of sets of beauties that were most often reused. The original background might be cut away, the set title changed and the colours and patterns varied. Actor prints were almost never recycled in this way in the nineteenth century. One Edo publisher, Sanoya Kihei, quite exceptionally reused actor print blocks on occasion, with unhappy but very instructive results. In 1835 the play *Sugawara and the Secrets of Calligraphy* (*Sugawara denju tenarai kagami*) was performed by an all-star cast at the Nakamura Theatre. Sanoya Kihei still had in his possession the blocks for a powerful set of half-length portraits of the leading characters in this play that Kunisada had designed in the late 1820s. Unfortunately for Sanoya Kihei, the roles were cast differently in 1835. Undeterred, he cut out the names and faces of the original actors on at least two of the old sets of blocks and replaced them with the names, poems and faces of the current performers.

Close comparison of the two states of one of these prints reveals much that is simply taken for granted when viewing woodblock prints (figs. 9 and 10). The actor's name and poem were changed easily enough, though

without much care for the overall balance of the composition. The insertion of the new face was more complicated and the plugging of the blocks to accommodate it is all too obvious. The publisher reduced the number of blocks employed to produce the reissue, thus omitting inner patterns on the kimono. The blocks themselves had not been well cared for. Note in particular the break at the top right point formed by the sleeve tossed behind the actor's head. Most striking, however, is the insensitivity of the printing and colouring of the reissue. The subtle tones of the original have been replaced by flat colours, while the carefully judged grey used for the keyblock and texts of the original has been replaced in the reissue by a thick, uniform black which hardens and clutters the design. In the original such a black had been confined to the actor's hair, pupils and blackened teeth. (Blackened teeth were fashionable among the aristocracy in the period in which the play was set, the early tenth century. In the Edo period the fashion persisted among married women.) The reissue hardly represents Kunisada's original intention, nor does it meet the standards the consumer had come to expect. Sanoya Kihei was responsible for the publication of many of Kunisada's finest designs from late 1820s into the 1850s. Perhaps pressure to publish quickly in order to cash in on a great hit drove him to allow such an inept reissue. This carelessness is all the more difficult to comprehend because this print was issued as part of a set that included the powerfully designed and brilliantly produced portrait of Ichikawa Danjûrô VII as Umeômaru (fig. 23). When we encounter such an exceptional lapse, we can better appreciate the high standard to which the overwhelming majority of actor prints were produced.

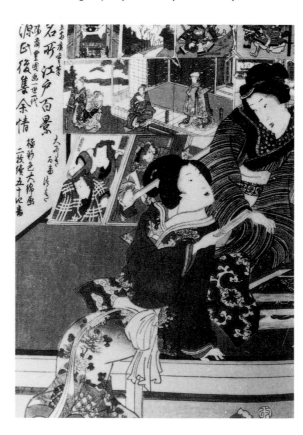

8. An Edo print shop, detail of a triptych from a set entitled 'An up-to-date parody of the four classes' (*Imayô mitate shi-nô-kô-shô*). Identifiable prints by Kunisada, Hiroshige, and others are displayed in the background. The notice to the left advertises sets of prints by Hiroshige and Kunisada. 1857. Private Collection.

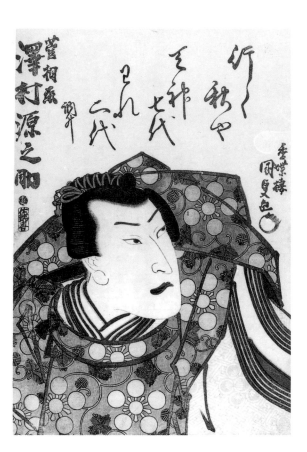
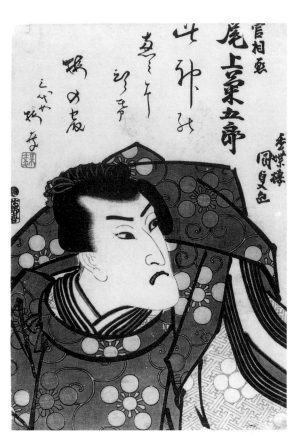

9. Sawamura Gennosuke II as Kan Shôjô in *Sugawara and the Secrets of Calligraphy (Sugawara denju tenarai kagami)*. Late 1820s. Private Collection.

10. Onoe Kikugorô III as Kan Shôjô in a production of *Sugawara and the Secrets of Calligraphy (Sugawara denju tenarai kagami)* at the Nakamura Theatre in late 1835. The blocks cut for the print illustrated in figure 9 were adapted to produce this print. Private Collection.

11. The Morita Theatre during a performance of '*Stop Right There!*' *(Shibaraku!)*. The hero, an actor of the Ichikawa line, is entering along the walkway on the left. Triptych. 1858. Sotheby's London.

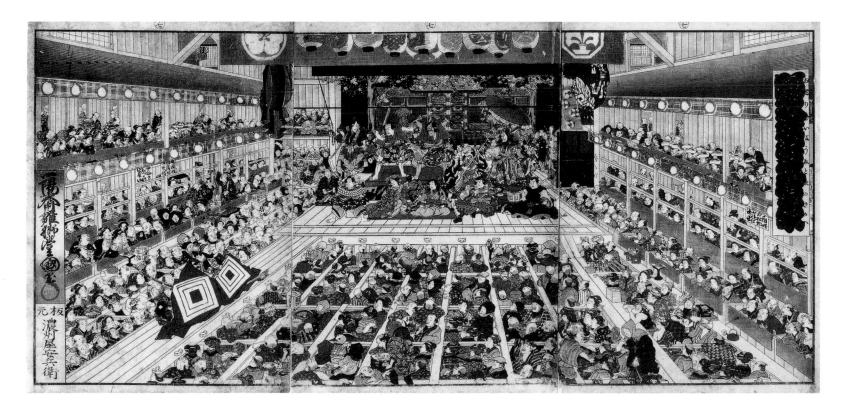

Reading a print

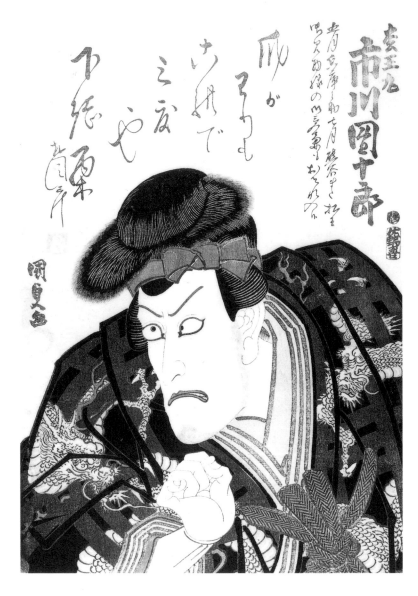

12. Ichikawa Danjûrô VII as Matsuômaru in *Sugawara and the Secrets of Calligraphy (Sugawara denju tenarai kagami)*. 1828. Private Collection. Also see colour plate 9.

1. *Sugawara and the Secrets of Calligraphy*, translated by Stanleigh H. Jones, Jr. New York 1985, p. 241.

How would this print have been read by a committed kabuki fan and print buyer when it was offered for sale in 1828? The largest characters inscribed at the top right of the print name the actor depicted: Ichikawa Danjûrô, one of the greatest and most popular of all nineteenth-century actors and the seventh to bear that name. To the right of his name in much smaller characters is the name of the role in which he is depicted: that of Matsuômaru, one of the heroes in the ever-popular historical drama *Sugawara and the Secrets of Calligraphy*. The artist's signature, 'drawn by Kunisada', which is written in characters of modest size and is followed by

his red *toshidama* seal, appears on the left edge of the print; it is balanced by the censor's seal and publisher's mark on the right edge of the print, just below Danjûrô's name. The two lines of cursive script to the left of the actor's name announce his forthcoming performances of other roles. The inclusion of such information underscores the ephemeral nature of actor prints. Above Danjûrô's head there is a poem of his own composition, written in his own hand in cursive script, signed 'Sanshô' and sealed. (Sanshô was the 'poetry name' used by bearers of the stage name Danjûrô.) The poem with its dense word play and multiple levels of meaning would have teased and delighted Danjûrô's fans, many of whom would also have been amateur poets. All the texts are printed in a diluted black ink to allow the figure - whose hair, outline and costume are printed in deepest black - to stand out all the more boldly from the plain ground. At the same time, the flow of the script from right to left reinforces the power-ful leftward thrust of the figure. The print was issued by the publisher Sanoya Kihei in connection with a production of the play that opened on the ninth day of the fifth month of 1828 at the Ichimura theatre. Make-up and costume indicate that Danjûrô is being shown in the fourth act of the play, which is entitled 'The Village Schoolroom'.

Matsuômaru makes his entrance in this scene in a palanquin, feigning illness. His unshaved forehead, unruly hair and purple headband tied on the left side of his head to bring relief from headache, all lend credence to his claim that he is ill and at the same time indicate to the viewer that he is in a state of extreme nervous tension. Although he is in the employ of the villain of the play, Matsuômaru here seeks to affirm his loyalty to his true lord, Kan Shôjô. The villain orders the murder of Kan Shôjô's young son, Kan Shûsai. He commands Matsuômaru to accompany the party of officers sent to capture and kill the boy,

because he is the only one who can identify him with certainty. Matsuômaru contrives to have his own son killed in place of Kan Shûsai. His son is murdered off stage, and it takes all his will to retain his composure at the muffled sound of the death blow. His son's severed head is then brought on stage in a box and laid before him. He opens the box, gazes on his son's head, and with complete self-control announces, 'Ah, that he has beheaded Kan Shûsai there can be no doubt, no question.'[1] Kunisada has depicted Danjûrô at this dreadful moment. We see the actor portraying Matsuômaru's pain as he is caught between paternal feelings and loyalty to his lord, but he knows where his duty lies. His excruciating inner struggle is expressed through the way in which he clenches his fist, grits his teeth and crosses his eyes, all elements of the pose *(mie)* appropriate to this moment. The costume worn by Danjûrô VII in this scene would have been decorated with snow-laden pine *(matsu)* branches. They not only recall the character's name but emphasise the tragic nature of the role. In this instance, Kunisada has chosen to depart from stage convention and depict the hero in a heavy overcoat *(haori)* decorated with roiled dragons, beasts associated with great strength and nobility. As used here, the dragons serve to amplify the force of Danjûrô VII's pose and reflect the turmoil of his emotions.

1. Onoe Matsusuke II (Kikugorô III) as
Rokusaburô the carpenter in the 1813
production of *Mijikayo ukina no
chirashi-gaki*

> From the retrospective set 'Great Hits
> of the Stage' *(Ôatari kyôgen no uchi)*
> 1815-16
> Signed: Gototei Kunisada-ga
> Published by Kawaguchiya Uhei
> Gerhard Pulverer, Cologne

In 1815-16 a set of prints of a kind not
seen in Edo for fifteen years appeared
for sale. It was entitled 'Great Hits of
the Stage' and consisted of seven bold
half-length portraits of the leading
actors of the day in their greatest roles,
placed against a ground of shining
printed mica. Throughout his career
Kunisada displayed an awareness of the
accomplishments of his predecessors
and often paid homage to them. How-
ever, this daring revival of mica-ground
half-length actor portraits was not con-
ceived as an act of homage, rather it was
an invitation to the print-buying public
to compare his work with the greatest
achievements of the earlier masters.

Hitherto actor prints had been
issued in response to current
performances. 'Great Hits of the Stage'
was different in that it was intended as
a retrospective survey. The earliest
performance commemorated in the set
had taken place in 1808. The print
illustrated here shows Onoe Kikugorô III
in the role of Rokusaburô the carpenter,
which he performed in 1813. Although
he is not named on the print Kikugorô
III, would have been immediately
recognisable because Kunisada
employed the 'standardised likeness' of
the Utagawa school in depicting him.

The freshness and strength of
Kunisada's depiction of the actor's face,
which the plain mica sets off to great
effect, is particularly impressive. Some of
his later actor portraits are more
adventurous in terms of design, but
none of them surpass the power of the
portraiture found in this set or match its
richness.

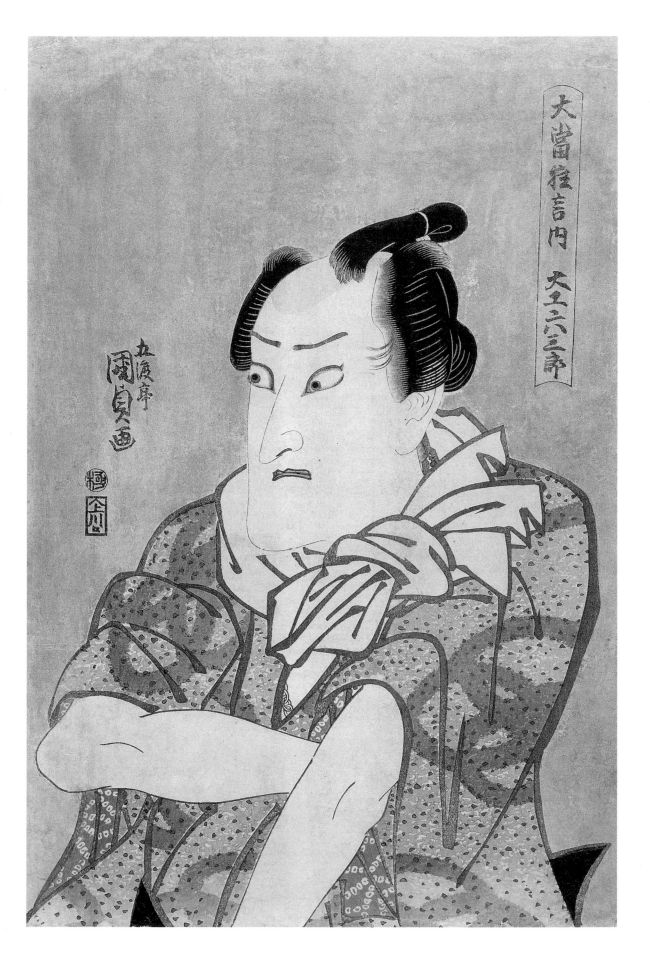

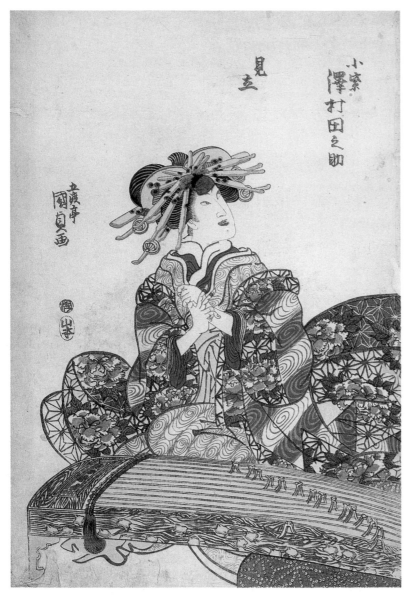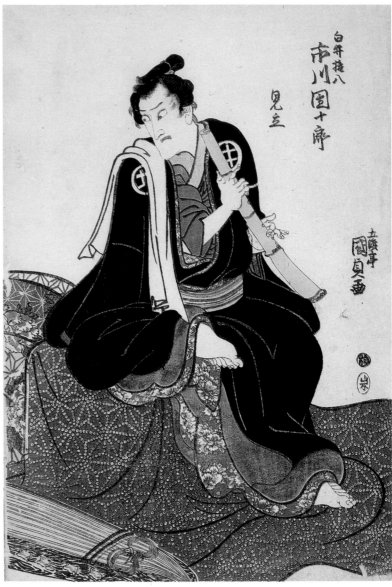

2. Ichikawa Danjûrô VII as Shirai Gompachi (right) and Sawamura Tanosuke II as Komurasaki (left) in an imagined casting of *Lover's Nightmare in the Yoshiwara (Hiyoku no chô ume no Yoshiwara)*

> Diptych
> 1813
> Signed on each sheet:
> Gototei Kunisada-ga
> Published by Yamamoto
> Trustees of the British Museum

Multi-sheet compositions - usually diptychs or triptychs - which presented actors in full figure, dominated Kunisada's theatre print production during the first forty years of his career. It was with these that Kunisada established his reputation as a designer of actor prints. In the diptych illustrated here Kunisada has portrayed Ichikawa Danjûrô VII, who was then a rising kabuki star, as the chivalrous but ill-fated commoner Shirai Gompachi, with his paramour, the courtesan Komurasaki. Sawamura Tanosuke II, who is shown in the role of Komurasaki, was one of the leading onnagata - male actors who specialized in female roles - of the period. His career was cut short by his death in 1817 at twenty-nine years of age.

The art of the onnagata developed as a result of a government edict of 1629 which banned women from the kabuki stage. A virtue was quickly made of this necessity. As Yoshizawa Ayame, a great onnagata of the early eighteenth century, explained, 'If an actress were to appear on stage she could not express ideal feminine beauty for she would only rely on the exploitation of her physical characteristics, and therefore could not express the synthetic ideal. The ideal woman can only be expressed by an actor.'[1] This passage provides an important key to understanding both the art of the onnagata and their depiction in prints.

Danjûrô VII holds a bamboo flute (*shakuhachi*) while Tanosuke II is fixing plectra to his fingers in order to play the *koto* that lies before him. The scene is labelled a *mitate* - Kunisada is not recording an actual performance but is presenting an imaginary casting. There is a tension about Kunisada's portrayal of the lean and large-eyed young Danjûrô VII that reflects his electrifying stage presence.

1. *The Words of Ayame (Ayame gusa)* as recorded by Fukuoka Yagoshirô, quoted in Ernst, *Kabuki Theatre*. p. 195.

3. Iwai Hanshirô V at the hour of the monkey (4 p.m.)
> From the set 'An Actor Sundial' *(Haiyû hidokei)*
> 1816
> Signed: Gototei Kunisada-ga with *mimasu* seal
> Published by Iwatoya Kisaburô
> Gerhard Pulverer, Cologne

This print comes from a rare set of six designs in which Kunisada linked the most exciting actors active in Edo in 1816 to six of the twelve two-hour periods *(koku)* into which the day was traditionally divided. He chose the daylight 'hours' from morning (8 a.m.) to early evening (6 p.m.). Kunisada implied a considerable degree of intimacy between the purchaser of these prints and the actors depicted in them by omitting the actors' names, implying that the purchaser knew them all by sight, and presenting them at their ease in summer *déshabillé*. Iwai Hanshirô V is shown at the 'hour' of the monkey (4 p.m.), fresh from his bath in a loose fitting summer robe *(yukata)*. His casual pose is ripe with seductive femininity. The upper part of his robe is decorated with his crest, the hem with irises. The irises recall his 'poetry name' 'Tojaku', the characters of which can also be read as 'irises' *(kakitsubata)*. The pinks growing behind him form a complicated pun on his 'shop name', Yamatoya. The presence of these complex visual and verbal puns in the print indicates the degree of sophistication Kunisada could assume on the part of his public.

Even though Hanshirô V is shown off stage and out of role, he is still dressed in women's clothes. Onnagata never shed their adopted gender. As the early eighteenth-century onnagata Yoshizawa Ayame explained, 'if he does not live his normal life as if he was a woman, it will not be possible for him to be a skilled onnagata.'[2] Onnagata took wives and fathered sons. Iwai Hanshirô V was even joined on the stage by two of his sons who performed to great acclaim as Iwai Kumesaburô II and Iwai Shijaku I.

2. *The Words of Ayame (Ayame gusa)* as recorded by Fukuoka Yagoshirô, in *The Actors' Analects (Yakusha rongo)*, edited and translated by Charles J. Dunn and Bunzô Torigoe. Tokyo 1969, p. 53.

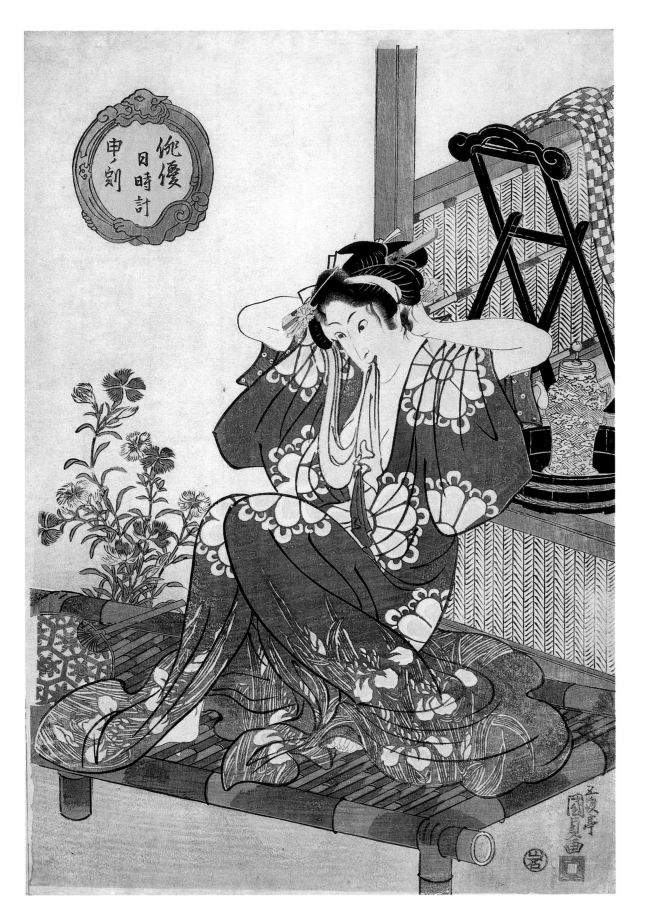

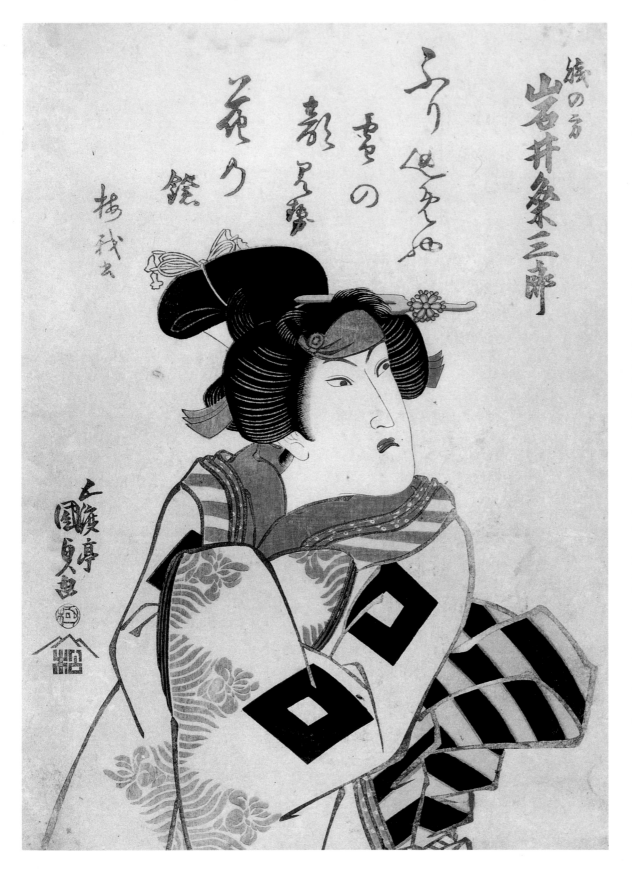

4. Iwai Kumesaburô II as Aya no Kata
in an unidentified play
From an untitled set
1822
Published by Matsumura Tatsuemon
Signed: Gototei Kunisada-ga
Private Collection

Kunisada produced this untitled set after a period of six years in which he did not design any half-length actor prints. It is characterised by striking compositions and an extreme delicacy in the printing. In the earlier sets Kunisada's debt to his teacher Toyokuni was still very much evident; here for the first time Kunisada reveals his mature style in the half-length actor format.

In the portrait of Iwai Kumesaburô II reproduced here, the sculpted black mass of the hair is balanced by bold black lozenges on the kimono sleeves and black stripes on the sash (obi). So as not to clutter the design, diluted black ink is used for the calligraphic strokes that define the kimono and sash as well as the actor's name and role, the artist's signature, the censor's seal and the publisher's mark. As an added refinement, the poem in Kumesaburô II's own hand is printed in pale green and the ground in pale pink. The pose suggests suddenly arrested movement, while there is much sensitivity in the drawing of Kumesaburô II's face. These facets of the design combine to produce an extremely effective portrait of one of the masters of the art of the onnagata.

5. Segawa Kikunojô V

From a set of prints entitled 'Firefly
catching - a line-up of Edo folk'
(Hotarugari - Edokko soroi)
Mid-1820s
Published by Yamaguchiya Tôbei
Signed: Gototei Kunisada-ga
Private Collection

This print of Segawa Kikunojô V comes
from a set that records a performance
of an unidentified play that appears to
have parodied the theme of the 'street
knights' or chivalrous commoners
(otokodate) of Edo. These men of the
people defended the weak against
wicked samurai and corrupt officials. In
this version female characters were
included in the line-up and the actors
appear dressed for a summer firefly
hunt. The print reproduced here comes
from a limited deluxe printing of this
design. It is on thicker paper and uses
more subtle pigments than those used
for the standard printing. It is not
known who commissioned deluxe
editions of commercial prints or how
many were produced.

This print sums up the tension
inherent in the art of the onnagata .
The purple patch covering Kikunojô V's
shaved pate and his coarse features
identify him as a man, yet in dress and
deportment he represents the essence
of femininity. So highly regarded was
the onnagata's expression of feminine
behaviour that fashionable women
based their own manners and bearing
on them.

The placement of the figure is
masterly, the sense of motion
beautifully conveyed. The impact of this
design is much enhanced by the care
with which it was printed and the
subtlety of the colours used.
Particularly effective is the wiping of
colour blocks to allow one colour to
shade gradually into another.

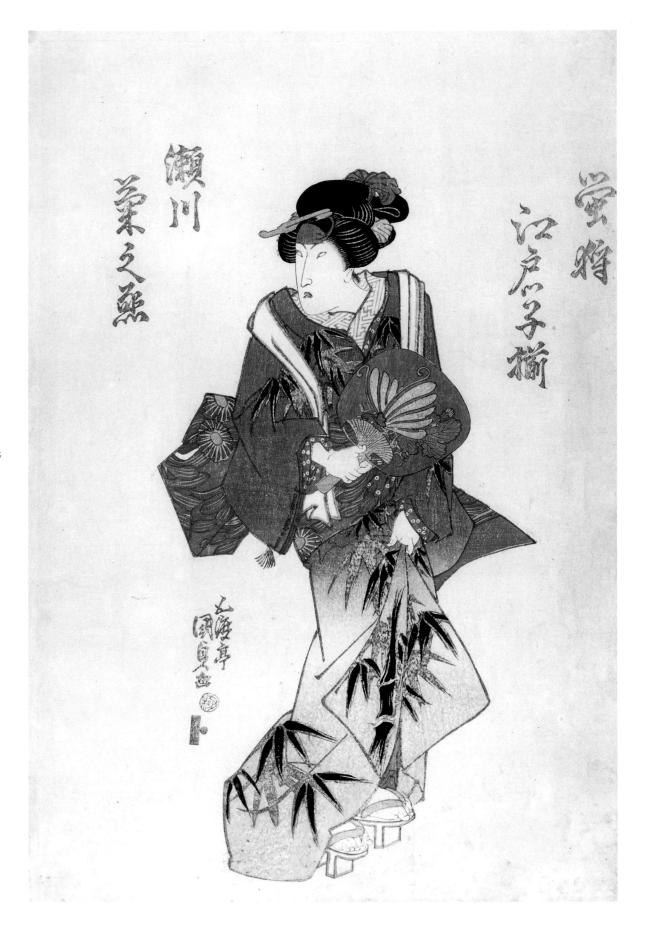

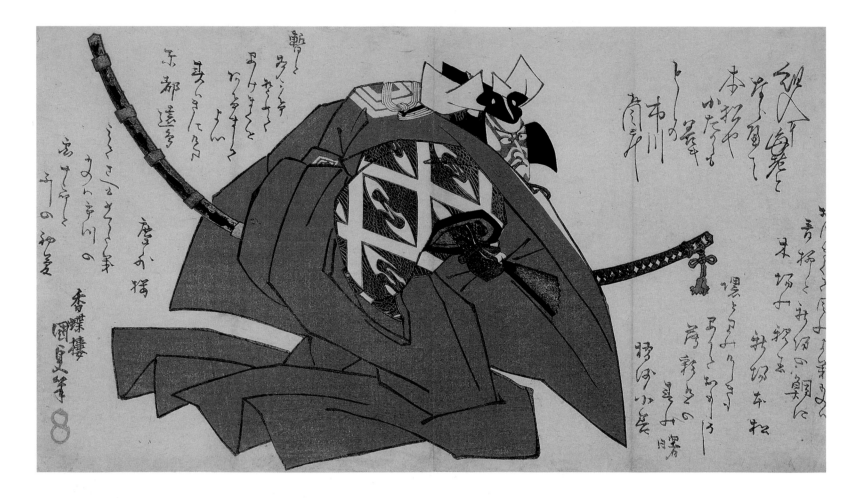

6. Ichikawa Danjûrô VII as the hero in
'Stop Right There!' ('Shibaraku!')

 Surimono diptych
 New Year 1832
 Signed: Kôchôrô Kunisada-hitsu with
 double *toshidama* seal
 Privately printed
 Robert Schaap, The Netherlands

This is one of the many surimono celebrating Ichikawa Danjûrô VII that Kunisada designed between the late 1810s and mid-1830s. Surimono are privately commissioned, luxuriously produced prints that were meant for limited circulation. In the surimono diptych illustrated here Danjûrô VII is shown in the costume worn by the protagonist in *'Stop Right There!'* *('Shibaraku!')*. This play was little more than a vehicle for the Ichikawa family, particularly those members of it who bore the name Danjûrô, to display their skill in the bold, swaggering 'rough business' *(aragoto)* style of acting. This style was developed in the last years of the seventeenth century by Danjûrô I, and came to be regarded as one of the distinctive features of Edo kabuki. In the play a villain is about to have his henchmen behead an innocent couple. Suddenly a great cry of 'Stop right there!' is heard from off stage and the hero makes a grand entrance along the raised walkway that passes through the audience. He pauses half-way to the stage to deliver a speech in which he boasts of his pedigree (fig. 11). Once

he reaches the stage he beheads a group of the villain's henchmen with a single blow of his great sword, releases the threatened couple and then makes a furious, bounding exit. In the Edo period the play was rewritten each year to introduce topical allusions, current slang and so on. Even the name of the hero changed. But the essential features of the play as outlined above were always retained. The content of this play was less important to audiences than the way it was performed.

Everything about the hero of this play is larger than life. The acting style is bombastic, the volume of the hero's costume is half as large again as it would normally be, his outer robe is brick red and strikingly decorated with the three concentric squares that form the Ichikawa family crest, the sword he wields is eight feet long, he wears striking make-up that consists of a white base with red lines drawn around the contours of his face, his wig has elaborate side projections, and he has paper 'wings' tucked into his hair to represent his vital energy. All of these aspects of the costume and make-up of

the role may be seen in this surimono. Kunisada has gone beyond recording the externals of the moment to convey, through his compression of Danjûrô VII's figure into a tight pose that presses against the top of the design, the power he brought to the role.

The poems inscribed on the surimono are by Danjûrô VII himself, by the ukiyo-e artist Kunimasa II, the printer Kozen, and two others. They wish the Ichikawa family prosperity in the coming year, 1832.

7. Ichikawa Danjûrô VII as Tsuna no Watanabe confronting Segawa Kikunojô V as the demon woman Ibaraki in *Modori Bridge (Modori-bashi)*

> Vertical surimono diptych
> c. 1830
> Signed on both sheets: Gototei
> Kunisada-ga with double *toshidama* seal
> Privately published
> Gerhard Pulverer, Cologne

This vertical surimono diptych, although slightly faded, still illustrates the care lavished on these remarkable products by both block-cutters and printers. Yet the richness and complexity of the printing were entirely at the service of the artist, who exploited them to enhance the impact of his designs. Kunisada here depicts the moment in the play *Modori Bridge* when the demon Ibaraki reveals her true nature to the hero Tsuna no Watanabe and he draws his sword to defend himself. He had been returning to Kyoto late one night when a beautiful young girl called to him and asked to be escorted back to her home. He was suspicious but also attracted by her beauty. As they walked on together his suspicion grew. When he finally confronted her, she revealed her true nature (indicated in the print by the Noh demon mask she holds in her left hand) and announced her intention to kidnap him. He drew his sword and when she grabbed him by the shoulder, he cut off her arm. The demon vanished leaving the arm behind. The drama and spectacle of the kabuki stage are captured in this diptych, which was commissioned by the Shippo-ren, a group of amateur poets. Metallic pigments were used to print the rain and lightning as well as the poems.

The role of Tsuna no Watanabe was another in which Danjûrô VII could display his skill in the portrayal of bold heroes. Kikunojô V was an accomplished onnagata with whom Danjûrô VII often performed in the 1820s and early 1830s.

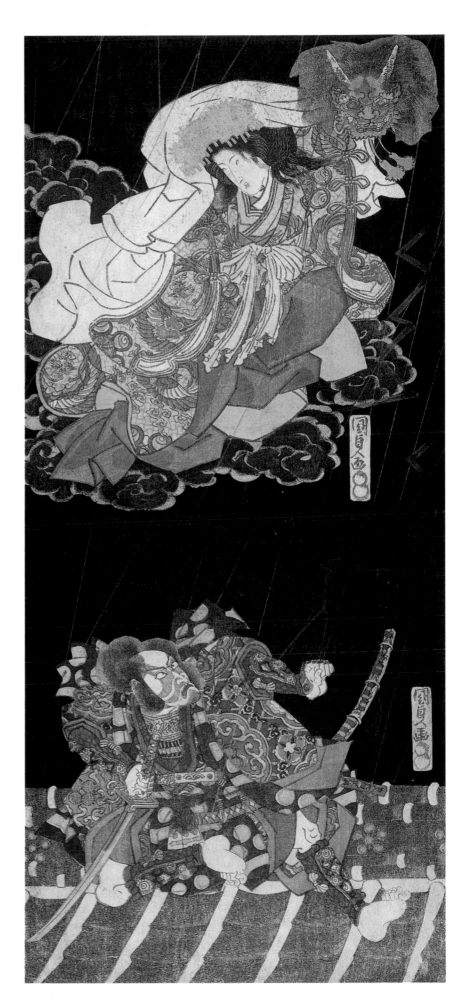

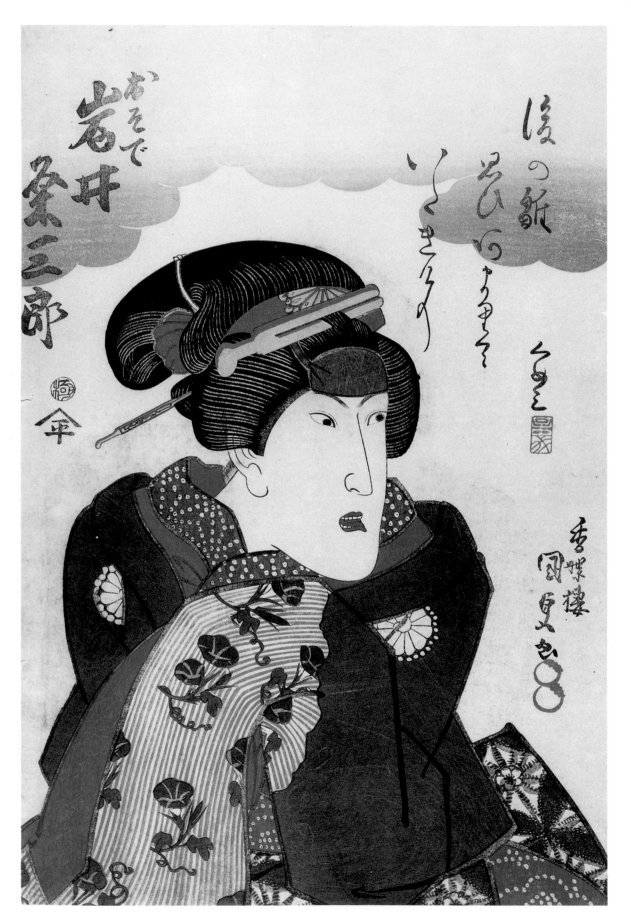

8. Iwai Kumesaburô II as Osode in
*Ghost Story at Yotsuya on the Tôkaidô
Highway (Tôkaidô Yotsuya kaidan)*
From an untitled set
c. 1830
Signed: Kôchôrô Kunisada-ga with
double *toshidama* seal
Published by Ômiya Heihachi
Private Collection

*Ghost Story at Yotsuya on the Tôkaidô
Highway* was first performed in 1825. It
was an immediate success and is still in
the kabuki repertoire. Osode's story is
a sub-plot of the main drama. She gives
herself to the man whom she believes
killed her fiancé in the hope that he
might assist her in avenging the murder
of her father and sister. She no sooner
surrenders to him than she discovers
that her fiancé is still alive. Torn
between the two men, she kills herself.
The convoluted plot establishes the
conflicts that are the stuff of kabuki. As
we look at this print we must
remember all that the woman depicted
has endured and appreciate the way in
which Kunisada has portrayed
Kumesaburô II's rendition of the
character's inner turmoil and tension.

Kunisada has drawn the outline of
the face with subtlety and feeling. The
flat, mask-like quality of the actor's
made-up face translates well to the
medium of the print. At the same time
the tight pose and the rich tones and
patterns of the kimono add to the
power of the print. The disposition of
the figure on the page is also masterly.
The identity of the actor and the
nuances of the role are conveyed by
minimal but extremely effective means.
Kunisada presents us with the bold
stage image that the theatregoer would
take away from a performance.

When we look at prints of
onnagata, we must remember that we
are being presented with images of
synthetic femininity in emotionally
charged poses. To the Edo connoisseur
the power and strength of the
onnagata's performance was to be
found in the 'strong line' beneath the
surface femininity that could only be
created by a man. That an actor might
be coarse-featured, even ugly, did not
detract from his ability to project a
vibrant theatrical image of femininity.

9. Ichikawa Danjûrô VII as
Matsuômaru in *Sugawara and the
Secrets of Calligraphy (Sugawara denju
tenarai kagami)*
> A single print
> 1828
> Signed: Kunisada-ga with single
> *toshidama* seal
> Published by Sanoya Kihei
> Private Collection

Kunisada's style proved an excellent
vehicle by which the drama and
excitement of the kabuki stage might
be captured in graphic form. This print
provides another example of Kunisada's
actor portraiture at its most powerful.
At the same time it drives home the
ephemeral nature of ukiyo-e prints. On
this print, two of Danjûrô VII's
forthcoming performances are listed.
Such topical information soon dated
any print. For a detailed explanation on
this print see the section above entitled
'How to read a print' (page 16).

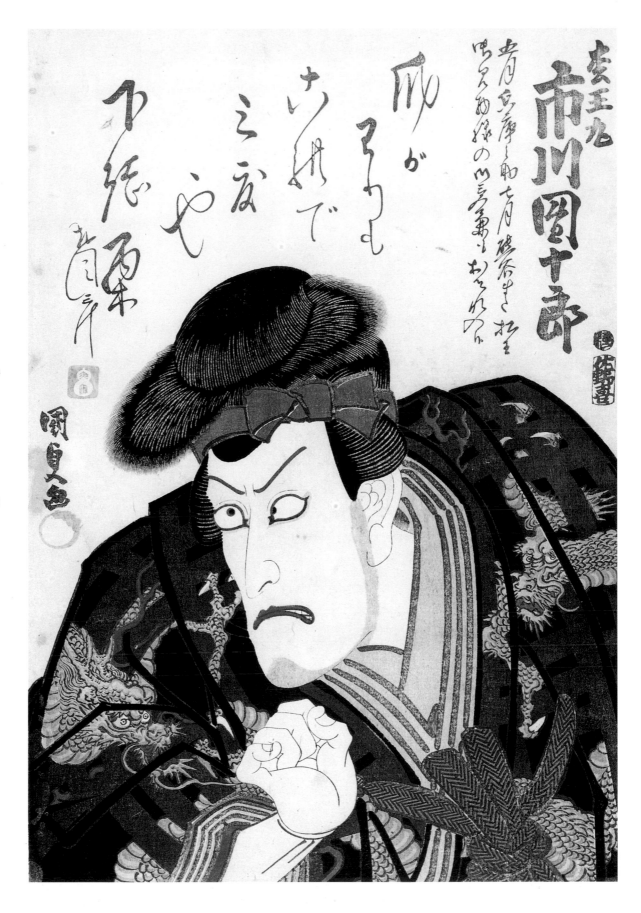

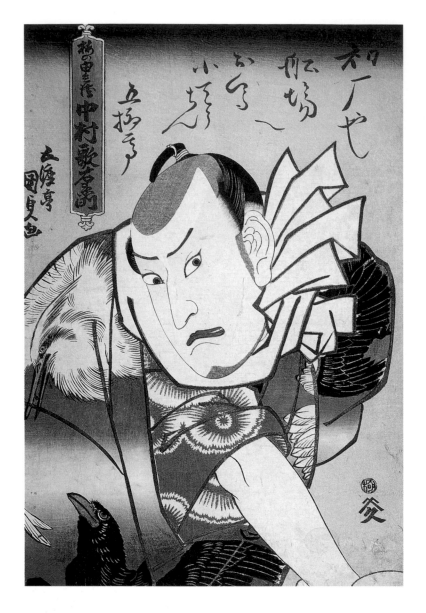

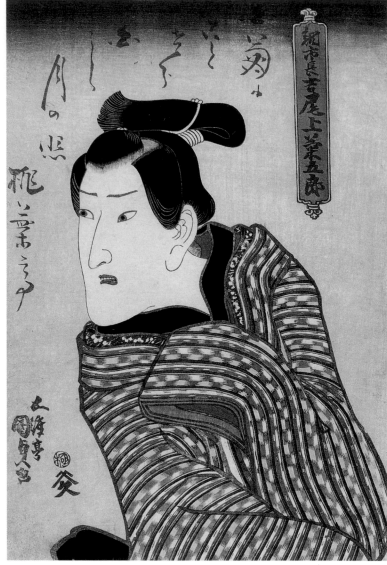

10. Onoe Kikugorô V as Chôfu no Chôkichi (right) and Nakamura Utaemon IV (Shikan II) as Ume no Yoshibei (left) in *The Character of a Geisha in the Sumida Spring (Sumida haru geisha katagi)*

> From an untitled set
> 1838
> Signed: Gototei Kunisada-ga
> Published by Yamamotoya Heikichi
> Private Collection

The most concentrated and powerful of Kunisada's commercially issued actor prints in the 1830s remained his half-length portraits. The pair illustrated here was issued in 1838 to record a production of *The Character of a Geisha in the Sumida Spring* performed at the Nakamura Theatre in that year. Nakamura Utaemon IV (previously Shikan II), a very popular actor who performed in both Edo and Osaka, took the role of Ume no Yoshibei (left). The crows and herons on the kimono immediately identify the character. Onoe Kikugorô III played the unfortunate young man Chôkichi (right). Yoshibei killed Chôkichi in order to obtain a sum of money, not knowing that by doing so he killed the younger brother of the woman he loved. The impetuous Yoshibei and the gentler Chôkichi are strongly contrasted by

Kunisada. The first is all restless energy; the second tense control. Each print can stand on its own but when they are paired, they make a memorable diptych. There is a subtlety and power about these designs and an assurance in their execution that is characteristic of Kunisada's finest work.

11. Segawa Kikunojô V as Ôiso no
Tora Gozen in *The Soga Brothers'*
Confrontation (Kotobuki Soga no Taimen)
 From the set 'An Imagined
 Confrontation of the Three Theatres'
 (San shibai mitate taimen)
 1832
 Signed: On-konomi ni tsuki Kôchôrô
 Kunisada ga ('Drawn by Kunisada by
 special request') with single *toshidama*
 seal
 Published by Sanoya Kihei
 Private Collection

A popular category of onnagata role
was that of the courtesan. In this
imposing half-length portrait we see
Segawa Kikunojô V as the courtesan
Ôiso no Tora Gozen, the paramour of
Soga no Jûrô, the older and gentler of
the two Soga brothers, whose tale of
revenge appeared in so many guises on
the kabuki stage. After the death of the
brothers, she and the mistress of the
younger brother not only took upon
themselves the task of informing the
men's aged mother of her sons' deaths,
but also played an active part in
avenging those deaths. A role such as
that of Ôiso no Tora Gozen, which
includes lyric passages, scenes of
amorous dalliance, gentle solicitude,
grim determination and farce, allows
the onnagata to display the breadth of
his acting ability. In this print Kunisada
presents Kikunojô V in the full robes
and luxurious hair ornaments of a
courtesan. The pose is flirtatious, the
bundle of tissues represents an
invitation to erotic dalliance, but there
is calculated determination in the
onnagata's glance. The set to which this
print belongs does not commemorate
a particular performance but offers the
leading actors of the three competing
Edo theatres as the cast for an
imagined performance of *The Soga*
Brothers' Confrontation.

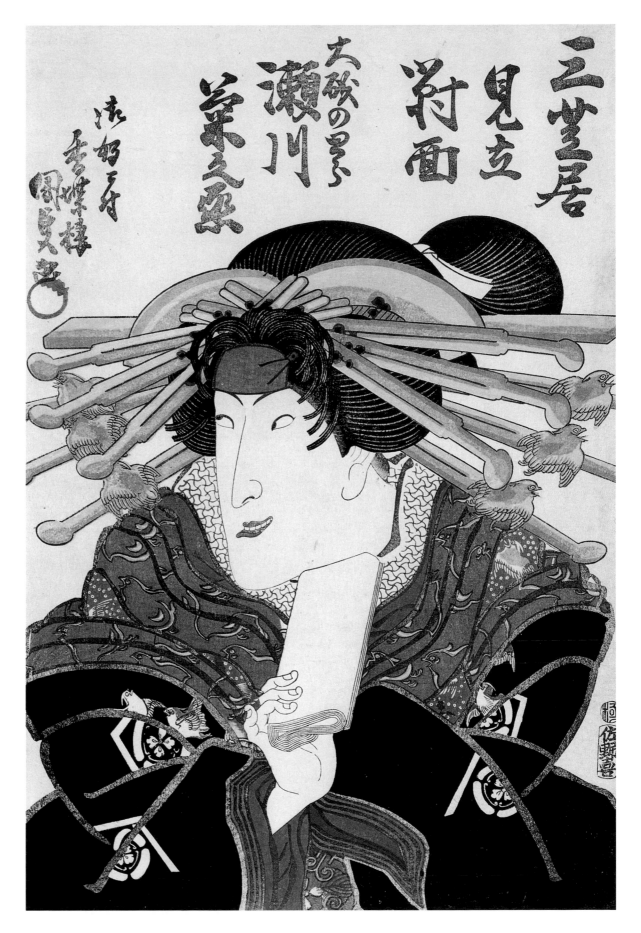

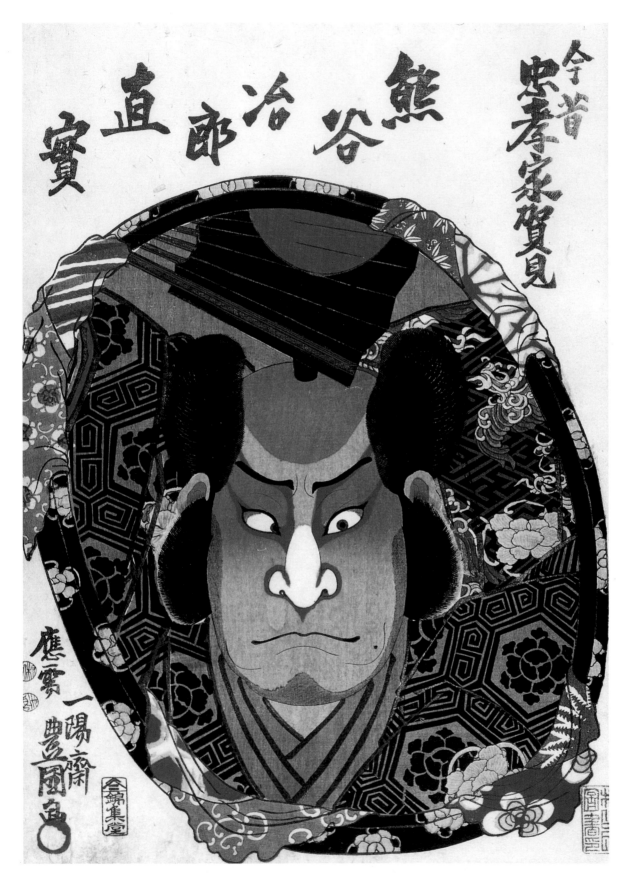

今昔忠孝家賀見

熊谷治郎直實

12. Nakamura Utaemon IV as Kumagai
Jirô Naozane in *Chronicle of the Battle
of Ichinotani (Ichinotani futaba gunki)*
　　From the set 'A Mirror of Past and
　　Present Examples of Loyalty and Filial
　　Piety' *(Konjaku Chûkô kagami)*
　　Late 1840s
　　Signed: Ôju Ichiyôsai Toyokuni-ga
　　('Drawn by request by Ichiyôsai
　　Toyokuni')
　　Published by Kinshûdô
　　Private Collection

Kunisada produced three sets of actor portraits reflected in mirrors resting in lacquer cases. The first appeared in the mid-1830s (fig. 1), the second in the late 1840s, and the third between 1858 and 1860. The print illustrated here comes from the second set. Because of the regulations of 1842 banning actor prints and enjoining publishers to issue in their place 'designs that are based on loyalty and filial piety', the actors depicted are not named, while the set bears an appropriate title. This token compliance with the regulations was sufficient to allow the set to pass the censors' scrutiny.

The actor in this print, Nakamura Utaemon IV (previously acting as Shikan II), would have been immediately identifiable, while the role in which he is depicted, that of the heroic Kumagai Jirô Naozane in the historical drama *Chronicle of the Battle of Ichinotani,* is emblazoned across the top of the print. Even the moment of the play in which Utaemon IV is depicted is recognisable. It is Kumagai's monologue in Act III in which he describes, with much play of his fan, how he fought and killed the handsome young Prince Atsumori. The historic Kumagai killed Atsumori on the beach at Ichinotani. On the kabuki stage a twist of the plot reveals, no doubt to the shock and delight of the audience, that Kumagai knowingly killed his own son in order to save the young prince. Both in history and on the stage, Kumagai is so shaken by events that he abandons the way of the warrior to become a Buddhist monk. In this powerful full-face portrait, Utaemon IV, rapt in his telling of the fateful battle, bears down on the viewer. His eyes cross as he assumes the set pose *(mie)* appropriate to the moment in order to underline the force of his emotion.

13. Seki Sanjûrô III as Koiiwa Hokaibô in *Shadows of another Day on the Sumida River (Sumidagawa gonichi no omokage)*, with a view of Tsumago in the background

> From the set 'The Sixty-nine Stations of the Kiso [highway]' *(Kiso rokujûku eki)*
> 1852
> Signed: Toyokuni-ga
> Published by Tsujiokaya Bunsuke
> Arendie and Henk Herwig,
> The Netherlands

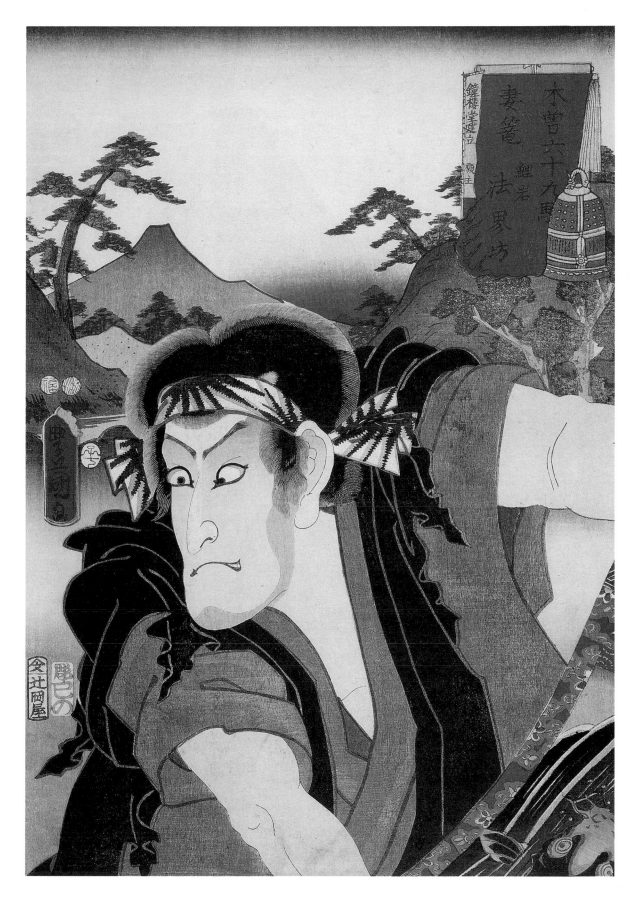

An extraordinary passion for half-length actor portraits by Kunisada against landscapes by or in the style of Hiroshige took hold of the print-buying public in 1852. These prints sold in record numbers and artists and publishers worked flat out to keep up with demand. By the end of that year, nearly 400 individual designs packaged into some eleven sets had been issued. The landscape is always the subordinate element; the figure of the actor dominates. Ornate cartouches that differ from print to print are the rule in these sets. The roles are indicated but no actor is named because of the lingering influence of the prohibitions of 1842.

The print illustrated here comes from 'The Sixty-nine Stations of the Kisô [highway]'. It presents Seki Sanjûrô III (1805-1870) as the dishonest and lecherous priest Koiiwa Hokaibô in ragged clothes with unruly hair sprouting on his unshaved head, holding a painting of a carp, the lost family treasure sought by the hero of the play. The hero had recovered the scroll and was excitedly discussing his success with his love when Hokaibô stole it from them, replacing it with a subscription list for a new temple bell. The bell worked into the lower right corner of the cartouche reminds the viewer of this deception. The figure is placed before the view of Mt. Fuji from Tsumago station. The depth of the landscape is enhanced by the wiping of the colour blocks to create subtle gradations of colour. The curve of the pine tree on the left balances the curve of the scroll. The agitation of the figure, expressed by the crossed eyes and clenched teeth, is reflected in the tatters of his robe and echoed by the ragged outlines of the branches of the pines on the hills behind him. The clarity, strength and immediacy of this design is typical of all the half-length portraits issued in 1852.

14. Ichikawa Danjûrô IX as the hero in *'Stop Right There!'* (*'Shibaraku!'*)
 A single print
 1864
 Signed: Shichijûkyû-sai Toyokuni hitsu ('From the brush of the seventy-nine-year-old Toyokuni')
 Published by Gusokuya Kahei
 Private collection

This print appeared in late 1864, shortly before Kunisada's death. In it the artist presents Danjûrô VII's fifth son as the hero of the play *'Stop Right There!'*. The role is one of the great examples of the 'rough' style of performance *(aragoto)* for which the Danjûrô line of actors was famous (see plate 6). This son had been adopted as a child by the Kawarazaki family of actors and managers, and first performed under the name Kawarazaki Gonjûrô. This print commemorates his performance of *'Stop Right There!'* in 1864 at the age of twenty-five. For that performance he used Sanshô as his acting name. (Sanshô had been the 'poetry name' of the bearers of the Danjûrô stage name.) He did not assume the stage name Ichikawa Danjûrô IX until 1874. As Danjûrô IX he played a central role in the preservation and development of kabuki in the Meiji period (1868-1912).

The Ichikawa family crest of three concentric squares appears prominently on the costume worn in this role. Kunisada manipulates the crests to form a nest out of which Danjûrô IX's head emerges. The impact of the design is heightened by the bold make-up and paper 'wings' tucked into the hair that are characteristic of this role. At top left there is a poem from the actor's own hand. Kunisada sets this powerful portrait in a triple frame that recalls the Ichikawa family crest. Kunisada proudly signed this compact, vigorous design as coming 'from the brush of the seventy-nine-year-old Toyokuni'. The years pass but the master's powers remain undiminished.

15. Sawamura Tosshô II as Nippon
Daemon conjuring frogs. From the
set 'Toyokuni's Drawings - a Magic
Contest' *(Toyokuni kigô - kijitsu kurabe)*
 1864
 Signed: Shichijûkyû-sai Toyokuni hitsu
 ('From the brush of the seventy-nine-
 year-old Toyokuni') and Kunihisa hoga
 ('Supplementary drawing by Kunihisa')
 Published by Hironoya Shinzô
 Private Collection

The supernatural figured frequently on
the kabuki stage and in popular novels
and, as a matter of course, in prints. In
the closing years of his life Kunisada
produced a number of sets of prints
devoted ostensibly to famous
magicians, but actually to their portrayal
by actors. In the print reproduced here
Sawamura Tosshô II is shown as the
thief-magician Nippon Daemon
conjuring toads out of snow, while a
great toad looms over the scene. The
overall design and the figure of Nippon
Daemon come from the brush of the
seventy-nine-year-old Kunisada but in
the foreground a second signature
announces that supplementary drawing
was provided by his pupil (and son-in-
law) Utagawa Kunihisa II (1832-1891).
This imaginative print is a fine example
of Kunisada's late full-figure designs.

16. Ichikawa Ichizô III as Saisaburô the barber in *Likened to Eight Views of Edo (Takurabete azuma hakkei)*

From the untitled set known as 'Famous Kabuki Actors Past and Present' *(Konjaku kabuki meiyû)*
1865 (posthumous issue)
Signed: Shichijûkyû-sai Toyokuni hitsu ('From the brush of the seventy-nine-year-old Toyokuni')
Published by Ebisuya Shôshichi
Robert Schaap, The Netherlands

In the short biography by the author Kanagaki Robun that appears on a diptych memorial portrait of Kunisada designed by his pupil Kunichika, the untitled set known as 'Famous Kabuki Actors Past and Present' is praised as the masterpiece among Kunisada's many sets of actor portraits. The set was innovative, the only one he ever designed in 'large-head' *(ôkubi-e)* format, and greater in scope than anything he had previously attempted, since he intended to provide nothing less than a survey of all the great actors of the preceding century. Compression, immediacy and clarity of design distinguish this set. The tight format, enhanced by the depth of the colours, the sharpness of the printing and the weight of the coloured backgrounds, thrusts the actors forward in a new and exciting way. The characterisation of the actors, many of them long dead, is forceful and utterly assured. The set provides a fitting climax to Kunisada's long career as a designer of actor portraits and at the same time it demonstrates that his creativity remained unimpaired to the very end.

The print from this magnificent set reproduced here depicts Ichikawa Ichizô III (1833-65) as the barber Saisaburô in an obscure play, *Likened to Eight Views of Edo,* performed in 1862. Kunisada completed and signed his design of the print in the following year, but it was not published until 1865, some months after his death. The tie-dyed kimono is meticulously rendered, the hands wonderfully expressive and the banded red, white and green background extremely effective in setting off the figure.

Kunisada's career

The early successes (1808-1821)

Kunisada was born into a relatively affluent commoner family in Honjo, an outer district on the east side of Edo, separated from the rest of the city by the Sumida River, and inhabited largely by merchants and artisans. He spent his entire life in that district. His father managed (or held shares in) a ferry, which was the fifth crossing on the Tatekawa, a small, canalised river that ran from east to west into the larger Sumida River. He was an active amateur poet and the school of poetry to which he belonged included actors of the Ichikawa family among its members. He died in the first year of Kunisada's life.

It is recorded that from an early age Kunisada was fond of ukiyo-e and amused himself drawing the likenesses of actors. Around 1800, when he was in his mid-teens, he was apprenticed to Utagawa Toyokuni (1769-1825), the leading actor print designer of the day. Toyokuni is said to have been astonished when he saw the boy's work and declared that he would certainly win praise and glory for his art.[1] Under his teacher he mastered the idiom of the Utagawa school, in particular the standardised 'true likenesses' (nigao) it used to portray the features of leading actors. In 1805 Toyokuni, along with a number of other ukiyo-e artists including Utamaro (1754-1806), fell foul of the authorities. Utamaro endured the most severe punishment: three days in prison and fifty days in manacles. This incident would have driven home the reality of government concern about and interference in publishing to the young Kunisada, about to launch his own career. Toyokuni provided his gifted pupil with the professional name Kunisada, which, as was customary, derived from the teacher's own name and proclaimed their teacher-student relationship.

Kunisada's earliest surviving signed and dated works appeared in 1807, when he was twenty-two. These include a triptych depicting a party of fashionably dressed women on the beach at dawn on New Year's day, and illustrations for a privately published book, written by the well-known author Taizawa Bakin, and intended as a New Year gift from a perfumer to his clients.[2] Kunisada's talent as a book illustrator was brought to the attention of a much larger audience in the following year with a commission to provide the line illustrations for a novel (gôkan) by Santô Kyôzan, one of the most gifted of the popular writers of the period. Gôkan - the literal meaning is 'combined volumes' - were long novels issued in many volumes, often over several years, in which text and illustrations were closely interwoven (fig. 13). The success of these works clearly depended as much on the illustrations as on the texts. Kunisada's illustrations scored a hit with the public, and he suddenly found

himself in great demand. Publishers' lists from 1808 onward reveal a flood of new titles illustrated by the young artist.

Some sense of the scale of the market for these illustrated novels may be gained from noting that in Edo in 1808, in addition to several hundred retail outlets known as 'picture-book stores' (ezôshiya), there were over 650 rental libraries, the latter figure rising to nearly 800 by 1830.[3] Although thousands of copies of a particular instalment of a novel might be sold, the widest audience was reached through rental libraries, which lent books for five days at a time for the small fee of 8 mon.[4] Some of these rental libraries had fixed premises, but most were run by pedlars who took the books to the readers in both the merchant and samurai quarters of the city. It was through this inexpensive and accessible medium that Kunisada's name first became widely known.

Sometime before 1810 Ôta Nampo (1749-1823), a very successful and highly regarded comic writer and poet, coined an art name (go) for Kunisada. It was customary for artists to use such names when signing their works. The name Ôta Nampo bestowed on the young artist - 'Gototei' (literally 'Fifth-ferry pavilion') - referred to the family business. Kunisada was not ashamed of the source of his family's prosperity and used the name more than any other when signing his prints and books in the 1810s and 1820s. His most common signature in those years read 'drawn by Gototei Kunisada' (Gototei Kunisada-ga).

Success came to Kunisada with startling rapidity and apparent ease. He did not suffer lean years, nor did he have to struggle for recognition.[5] Publishers had faith in him and sought to advance his career. For example, in

1. These observations are be found in the author and journalist Kanagaki Robun's obituary of Kunisada that forms part of the diptych memorial print designed by Kunichika and published in 1865.

2. The triptych is illustrated in Shigeru Shindô, *Kunisada's Actor Portraits*. Tokyo 1993, p. 128. For the booklet, see the discussion in Andrew Lawrence Markus, *The Willow in Autumn: Ryûtei Tanehiko, 1783-1842*. Cambridge, Massachusetts 1992, p. 80.

3. Katsuhisa Moriya, 'Urban Networks and Information Networks' in *Tokugawa Japan*, p. 117.

4. Akai, 'Common People', p. 189.

5. His career may be contrasted with that of his younger contemporary, Kuniyoshi (1797-1861), also a student of Toyokuni, who struggled for many years before finally achieving success as a print designer.

13. Illustration from the five-volume novel *Pine Branch of the Morning Audience (Kesa gozen misao no matsu-e)* written by Oka Yamashima. 1811. Private Collection.

1810 Nishimuraya Yohachi, proprietor of the great Edo print publishing firm Eijudô, invited Kunisada, along with the most distinguished ukiyo-e artists of the day, to contribute to a collective painting (gassaku) of the seven gods of good fortune.[6] The painting is also graced with inscriptions by the authors Santô Kyôzan and his brother, Santô Kyôden. Nishimuraya Yohachi had published numerous works by these artists and authors, who were all much older than the twenty-four year old Kunisada. By linking Kunisada with such illustrious names in this painting the publisher was seeking to promote his reputation among connoisseurs of ukiyo-e.

In the same year, the comic author Shikitei Sanba revealed the extent to which Kunisada's reputation had penetrated the populace at large in a passage in the second volume of his *Bathhouse of the Floating World (Ukiyoburo)*, a work that consists entirely of the ebb and flow of conversations in a public bath house. At one point one mother says to another:

> And then my third one, the oldest boy, buys those - what are they? *gôkan* - those little illustrated novels, anyway, and *they* pile up in a *basket*. Toyokuni's the best!' 'Kunisada's the best!' - they even learn the names of all the illustrators! Children these days are up on simply everything.[7]

Within two years of his debut Kunisada's name was already on the lips of children. An entry in Shikitei Sanba's diary from the summer of 1810 provides further evidence of Kunisada's rapid rise: 'From 1809 onward, [Kunisada] only increased in popularity, and currently [July 1810] he is the star attraction of his entire school.'[8] Some years later the author Bakin, who had himself been engaged in a widely acclaimed collaboration with Hokusai since 1805, praised the 'consummate skill' of Kunisada's book illustrations.[9]

Kunisada produced his first actor print in 1808 and thereafter quickly established himself in the first rank of kabuki actor print designers in Edo. A table of ukiyo-e artists compiled in 1813 placed Kunisada second after his teacher Toyokuni, but when large numbers of their actor prints of the 1810s are compared, it becomes apparent that Toyokuni, despite his outstanding past achievements, could no longer match the vigour of his brilliant pupil's print designs. Kunisada's style in this period was spiky, crackling with energy, a perfect vehicle for conveying the excitement generated by the best kabuki actors in their performances.

Kunisada was particularly inspired by the young actor Ichikawa Danjûrô VII. The two men were near contemporaries: Kunisada was born in 1786 and died in 1865; Danjûrô VII was born in 1791 and died in 1859. Danjûrô VII's first great stage success occurred in 1811, at the very time that Kunisada was establishing his reputation as a designer of actor prints. Over the next fifty years Kunisada would chronicle Danjûrô VII's dazzling career, providing hundreds, if not thousands, of images of him on and off stage, through his youth, maturity and old age. He depicted Danjûrô VII more

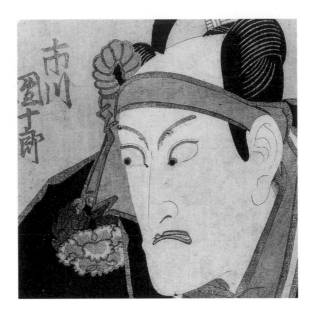

14. Detail of a fan print of Ichikawa Danjûrô VII as Sukeroku. 1819. Private Collection.

frequently than any other actor, both in commercially issued prints and privately issued surimono, and gave him pride of place in his books devoted to actors. He also collaborated with Danjûrô VII on some twenty illustrated novels.[10] It might be argued that Danjûrô VII's eminence in the world of kabuki determined his prominence in Kunisada's output, but Kunisada's relationship with him appears to have been more than merely professional. Kunisada based a seal he used in his early years on Danjûrô VII's family crest, he was active in one of the actor's many fan clubs, and compiled poetry anthologies in Danjûrô VII's honour. Whatever their personal relationship, Kunisada (and his publishers) profited from the public's insatiable appetite for images of the great star, while Danjûrô VII found in Kunisada the perfect agent for projecting his carefully cultivated public persona to the widest possible audience.

The overwhelming majority of Kunisada's actor prints in the 1810s consisted of highly charged diptychs and triptychs depicting actors in role (plate 2). However, in 1811 and 1812 he also delighted his public with triptychs that offered complex, panoramic views of the backstage areas of the three great Edo theatres. Dozens of figures of actors, each precisely depicted and carefully identified, fill these designs. The actors are shown engaged in a variety of activities. Some are making up their faces, others studying roles, some are conversing over cups of tea, and yet others are dining. As a group, these triptychs offer a comprehensive overview of the contemporary kabuki establishment in Edo.[11] In this period Kunisada also produced a number of three- and five-sheet compositions and sets of prints that provided closer views of favourite actors at their leisure visiting shrines, picnicking, and so forth. In a particularly elegant set issued in 1816 he linked full-length portraits of actors at their ease with the hours of the day (plate 3). There were distinguished precedents for all of these categories of actor prints; Kunisada imbued each with his characteristic vigour.

6. The painting is in the Chiossone Collection in Genoa. It is illustrated in Jenkins, *The Floating World Revisited*, p. 175 (Exhibit III-6) and in Sebastian Izzard, *Kunisada's World*. New York 1993, p. 21, fig. 2. The other contributors were Kunisada's teacher Toyokuni, Toyoharu, the retired founder of the Utagawa school, Kiyonaga, head of the Torii school, Shun'ei, head of the Katsukawa school, and Hokusai, who led his own distinctive ukiyo-e school.

7. Robert F. Leutner, *Shikitei Sanba and the Comic Tradition in Edo Fiction*. Cambridge, Massachusetts 1985, p. 175.

8. From *Shikitei zakki*, quoted in Markus, *Willow in Autumn*, p. 80.

9. Quoted in ibid., p. 78.

10. Ichikawa Danjûrô VII was involved in writing about forty-five *gôkan* between 1814 and 1839. Other artists, including Toyokuni, Kuniyoshi and Eisen, collaborated with him on individual titles, but no one else illustrated as many as Kunisada. See Satô Satoru, *Yakusha gôkan shû*. Tokyo 1990, pp. 435-441.

11. Early in 1813 Kunisada designed a pentaptych offering a similar panoramic view of one of the great brothels of the Yoshiwara, the second pole of the floating world.

15. Detail of a print of Ichikawa
Danjûrô VII as Matsuômaru. 1828.
Private Collection.

16. Detail of a print of Ichikawa Ebizô V
(Danjûrô VII) as Banzui Chôbei.
1859. Private Collection.

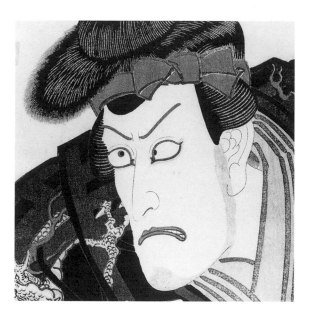

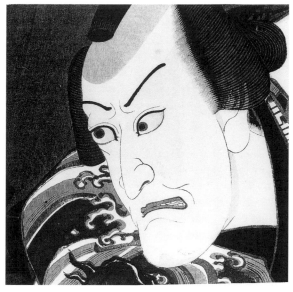

Throughout his long career Kunisada adhered to the standardised 'true likenesses' of the Utagawa school in which he had been trained when depicting actors. Nonetheless, his adherence to those 'true likenesses' was anything but mechanical; he employed them with flexibility and sensitivity. With a career that spanned six decades Kunisada had to deal with the aging of his subjects and it is instructive to see how he did so within the constraints of his art. The face of Ichikawa Danjûrô VII from a print issued in 1819, when the actor was twenty-eight, may be compared with his face in a print issued in 1828, when the actor was thirty-seven and at the height of his powers, and again with his face in a print issued in 1859, when he was sixty-eight and just months from his death (figs. 14, 15 and 16). Those features that comprised Danjûrô VII's 'true likeness' remained constant, but the passage of time was not ignored. The line of the nose, the jaw and the chin as well as the large eyes are the same in all three portraits. In the second, minor adjustments to the outline of the face transform youthful leanness into the fullness of middle age. In the third, the addition of a few lines about the nose, mouth and eyes and a sharpened angularity in the outline of the face are sufficient to suggest the loosening of the skin over the facial bones and to transform the face into that of a man well into his sixties. Kunisada's great achievement in his actor portraits was to remain faithful to the conventions of his school without compromising the freshness and excitement of his images.

In the same decade that Kunisada perfected his portrayal of actors, he also established his reputation in the other great print genre, that of 'pictures of beautiful women' (bijin-ga) through a succession of boldly designed sets of beauties. Again he harked back to the past glories of this genre while creating fresh new images. Here, however, his dominance of the field was not unchallenged. Kunisada competed on equal terms with Eizan (1787-1867) and Eisen (1790-1848). Eizan ceased designing prints in the 1820s, and thereafter Kunisada shared the honours in this field with Eisen and later with Kuniyoshi

(1797-1861) (fig. 17). Each of these artists offered the public his own distinct and bewitching image of female beauty.

Kunisada's fresh and exciting prints of actors and beauties produced in the 1810s consolidated his position in the public eye, not only as heir to his teacher Toyokuni, but also as the successor of past masters such as Sharaku (active 1794-95) and Utamaro. Confident of his powers, Kunisada sought not only to excel all his contemporaries (including his teacher), but also to emulate the achievements of the great masters of the previous generation. His most obvious act of emulation was embodied in the set of seven half-length actor portraits against a plain mica ground entitled 'Great Hits of the Stage' (Ôatari kyôgen no uchi), which he designed in 1815-16 (plate 1).

Artists first experimented with half-length actor portraits in 1780 but the format did not come fully into its own until the early 1790s, when it was brilliantly exploited by Utamaro for portraits of beautiful women and then, in the middle years of the decade, for actor portraits by artists such as Sharaku and Toyokuni. The impact of many of these bold portraits was enhanced by setting them against a glimmering plain mica ground. Shun'ei (1762-1819) was the first to employ a mica ground in a small group of actor portraits issued in the first month of 1794. By the fourth month, mica ground designs by Sharaku and Toyokuni were in the shops. The heyday of these opulent prints was short: by 1800 they were no longer being produced. It is likely that publishers ceased issuing them because of a government ban. While no text for such an order survives, there is an order issued in 1800 prohibiting the production of 'large-head' prints. In 'large-head' prints (ôkubi-e) nearly the entire surface area is taken up by the shoulders and face of the figure depicted. The result can be very powerful. The order banning such prints condemned them for being 'too conspicuous'.[12] In the mood then prevailing in official circles it is unlikely that the use of a shimmering mica ground on prints of lowly actors and

12. The 'large head' format was not to be seen in Edo again until 1860 with the appearance of the first prints in Kunisada's only set of 'large head' actor portraits, which is known as 'Famous Kabuki Actors Past and Present' (Konjaku kabuki meiyu), see below, p. 46.

registered prostitutes would have met with anything but disapproval. Despite these prohibitions, Toyokuni continued producing distinguished half-length actor portraits after 1800 without official interference.

When Kunisada produced his 'Great Hits of the Stage' set, he and his publisher boldly revived the use of a mica ground. By doing so they left no doubt that they wished these half-length portraits to be compared with the greatest achievements of the past masters of the genre. With this bold gesture Kunisada proclaimed his own and his publisher's confidence in his art.

'Great Hits of the Stage' is also remarkable in that unlike the vast majority of actor prints, which were issued in response to current performances, it provided a retrospective survey of the past hits of the finest actors then on the stage. Thus, the earliest performance illustrated in the set dates back to 1808, a full eight years before it was issued.

Although Kunisada's debt to the past is obvious in his designs of the 1810s and many of his most outstanding achievements in that decade were created in emulation of the achievements of past masters, there was little danger of confusing his work with that of any other artist. It was already marked by his distinctive artistic personality. It was through the explorations and experiments of the 1810s that he developed his mature style, which was fully established by the early 1820s.

The established artist (1822-1844)

Kunisada's career prospered and he lived well. He dressed elegantly and could afford to keep a mistress. Publishers besieged him with their requests, and in order to meet the ever-increasing demand for his designs, he began to take on students. By 1828 he had eleven assistants. When his teacher Toyokuni died in 1825, Kunisada, as his most gifted pupil, expected to succeed to his name. The coveted name went instead to Utagawa Toyoshige (1777-1835), a less distinguished artist who was married to Toyokuni's daughter.

Undeterred, Kunisada continued to produce the most popular actor prints of the day and to maintain his reputation as one of the foremost designers of prints of beautiful women and illustrations for novels. In this period he also established his reputation as a designer of volumes of erotica (shunga). Most of his prints of the 1820s and 1830s were issued as diptychs or triptychs or in sets of five, seven or ten individual designs. Single-sheet prints were uncommon, usually being issued only to commemorate events such as an actor's death, name change, departure from Edo or return to the Edo stage. So voracious was the public's appetite for actor prints that Kunisada could not avoid heavy reliance upon assistants when producing the thousands of designs needed to satisfy it. Although Kunisada's students may have mastered all the components of his style, they could not capture the freshness and raw energy that distinguished his actor prints in the 1810s. Thus among the vast number of actor prints bearing Kunisada's

signature issued in the late 1820s and 1830s there is not only an element of repetition, but also at times a flatness. Nevertheless, many very fine designs can be found among them and all were well printed.

Among Kunisada's most arresting actor prints from these years are his half-length portraits. He produced fewer than two hundred such designs between the early 1810s and the early 1840s - a very small part of his total output in that period - but they are all of such a consistently high quality that there can be little doubt that they are entirely the work of the master. They represent his actor portraiture at its very best. No other artist active in Edo at that time produced a comparable group of prints.[13]

Kunisada produced four sets of half-length actor portraits in the 1810s, the last appearing in 1816. He returned to the format six years later, after a visit to Osaka with a group of leading Edo kabuki actors in 1821/22. He may have been inspired by the striking half-length actor portraits being designed in Osaka at that time by Hokushû (active 1810-1832). Whatever the stimulus, shortly after his return from Osaka he produced a set of half-length portraits of actors in role with poems of their own composition, written in their own hand, printed above them. In this recently discovered set, the actors are depicted from the waist up and are smaller in scale relative to the sheet than was usual. The individual designs are characterised by varied and striking poses, a subtle range of colours and great delicacy of printing (plate 4).

Poems (or texts) of any kind were not a feature of the commercially issued half-length portraits of Kunisada's predecessors, nor had they appeared on any of his own earlier sets of half-length portraits. The combination was found previously only in Toyokuni's two-volume A Mirror of Actors Compared (Yakusha awase kagami) of 1804, which was intended for a much more restricted and affluent market than commercially issued prints. Their inclusion in this set thus marks a major new departure. Over the next two decades nearly all of Kunisada's half-length portraits carried poems or, less commonly, transcriptions of famous stage speeches.

Kunisada's inclusion of poems on half-length actor portraits of the 1820s and 1830s occurred in response to a mania that had taken hold of people of all classes and places in the first half of the nineteenth century for the composition of seventeen-syllable haikai poetry. At that time, "an ability to compose haikai became a social accomplishment, indispensable at parties".[14] These poems were without depth or spontaneity; overloaded with word play they rarely offered more than the reworking of well-worn themes according to rigidly observed rules. Poetry of this order has been summed up by Donald Keene, an enthusiastic and sympathetic student of Tokugawa literature, as 'a "second class art," agreeable to compose and publish, but seldom worth the effort to read.'[15] However limited the literary achievements of these amateur poets, their desire to have their poems printed led to the creation of many remarkable surimono and some of the finest of all Japanese illustrated books.

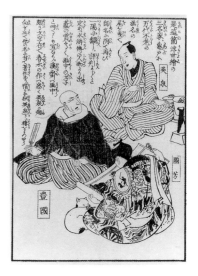

17. Kunisada (centre left) with his fellow artists Eisen (top right) and Kuniyoshi (bottom right), from Kuniyoshi's two-volume Biographies of Japanese Eccentrics (Nihon kijinden), 1846. Gerhard Pulverer, Cologne.

13. For a detailed discussion of this group of prints see Ellis Tinios, 'The Kunisada-signature Half-length Actors Portraits of Utagawa Kunisada' in Andon 40 (1992), pp. 110-126.

14. Keene, World within Walls, p. 360. Haikai are sometimes referred to as haiku, but the word haiku is a late nineteenth-century invention.

15. Ibid., p. 362.

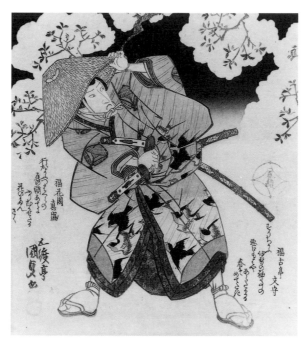
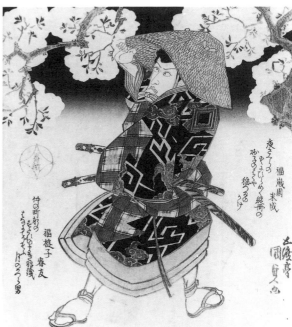

18. Ichikawa Danjûrô VII as Fuwa Banzaemon (right) and Onoe Kikugorô III as Nagoya Sanza (left) in a production of *Scabbards touching in Nakano-chô (Nakano-chô saya-ate)* at the Kawarazaki Theatre in 1827. Surimono diptych. Gerhard Pulverer, Cologne.

16. Kunisada also designed half-length portraits of beautiful women in the same period. His first set of half-length beauties appeared in 1822, and over the next fifteen years he designed eight further sets, producing a total of no more than fifty-five individual designs. He did not dominate this field as he did that of actor portraits; Eisen had made half-length beauties his speciality and provided stiff competition.

17. See Ellis Tinios, 'Three early uchiwa prints by Kunisada' in *Andon* 47 (1994), pp. 88-93.

18. In addition to actor portraits, the majority of which show the actors full-figure, Kunisada's surimono include a few beauties, a haunting night view of a city street, and a very small number of still lifes. Not surprisingly, the actor most often encountered in Kunisada's surimono is Ichikawa Danjûrô VII.

19. Jack Hillier, *The Art of the Japanese Book*. London 1988, pp. 216-217.

Actors were caught up in this mania, and their followers were eager for examples of their poetry and calligraphy. A lucky few might possess fans inscribed with a poem by their favourite actor, but the majority had to be content with examples of their idols' poetry and calligraphy reproduced on commercially issued prints.

Kunisada went on to design twenty more sets of half-length actor portraits between 1822 and the late 1830s, to produce a total of some 125 individual designs.[16] In a number of these sets he experimented with framing the portraits within devices such as folding fans (ôgi), battledores, round mirrors, fixed-frame oval fans (uchiwa), rectangular mirrors, sake cups, open books, and incense boxes. The results are often very exciting, for the compression of the half-length portraits within these devices tends to heighten their impact.

Throughout his career Kunisada also designed many half-length actor portraits for use on fixed-frame oval fans. These were cheap and colourful fashion accessories used by men and women alike. The few that have survived demonstrate Kunisada's mastery in fitting powerful actor portraits within the confines of the format, and equal his other print designs.[17]

Because of the wider audience for which they were intended all of Kunisada's commercially issued actor prints, including his fan prints, provided information that had been omitted from those issued in earlier decades. This information included the actors' names and the roles in which they were depicted. Consequently the viewer required less expertise to understand them. While Kunisada's prints were more immediately accessible, the regular inclusion of the actors' poems or speeches on his half-length portraits added a new layer of information for the viewer to absorb and savour.

Kunisada was also actively involved in the production of surimono from the late 1810s to the middle years of

the 1830s, when the economic crisis that had overtaken Japan brought an end to such extravagant trifles. It is estimated that he designed at least 300 of them. Surimono were intended to display the wealth and taste of the individual or individuals who commissioned them. For the artist they represented high-profile commissions executed in close consultation with the leading connoisseurs, poets and actors of the day. A wide range of subjects were depicted in surimono, but most of those by Kunisada were devoted to kabuki actors (plates 6 and 7 and figs. 4 and 18).[18] Kunisada did not delegate their design to assistants; the surimono bearing his signature are entirely his work. Thus, there is never anything flat or mechanical about them, even though their subject matter is identical to that of the commercially issued actor prints of the same years. In them we encounter once more the tension that made his actor prints of the 1810s so exciting. At the same time, Kunisada exploited the richness of the format to produce prints of extraordinary elegance and opulence. His surimono include many of the finest prints he designed in this period.

In the busy and prosperous 1820s, Kunisada found time to immerse himself in the study of the art of Hanabusa Itchô (1652-1724). Itchô, a rebel who stood in antithesis to the formality of academic Kanô school painting, was particularly admired for his extempore drawings, 'witty trifles, swiftly rendered anecdotes, or sketches made spontaneously without thought for further use.'[19] Kunisada sought instruction in Itchô's style from Hanabusa Ikkei (1749-1844), the then head of the school that Itchô had founded. With the exception of those exceedingly rare prints in which Kunisada transcribed a painting by Itchô or incorporated one of Itchô's designs on a screen or other accessory, it is impossible to discern the impact of his studies on his prints. Nonetheless, Kunisada considered his debt to the

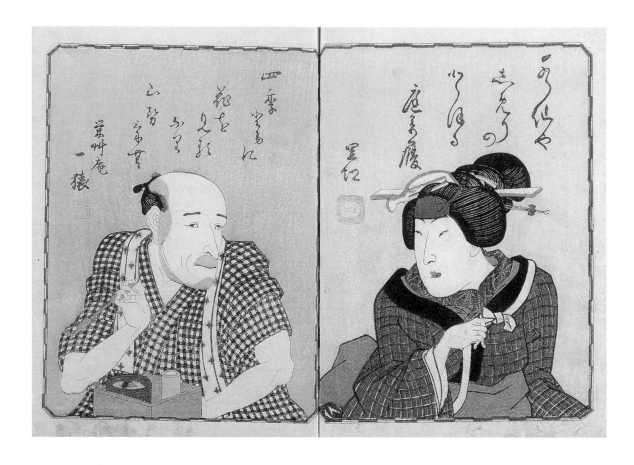

19. Portraits from *A Collection of Thirty-six Flowers of the Stage (Yakusha sanjū-rokkasen)*. Yamashita Kinsaku (right) and Bandô Hikozaemon XII (left) in roles from 'domestic dramas' *(sewamono)*, which dealt with contemporary life. 1835. Gerhard Pulverer, Cologne.

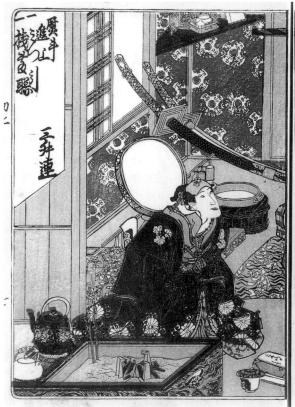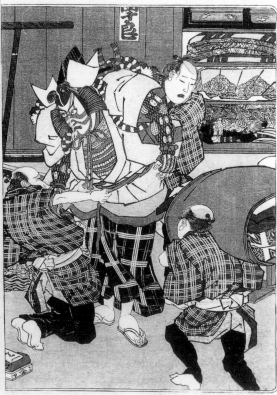

20. Illustration from the four-volume *Biographies of Eccentric Actors (Yakusha kijinden)*. Ichikawa Danjūrô VII chatting with Iwai Hanshirô V as three assistants dress him for the lead role in *'Stop Right There!' ('Shibaraku!')*. 1833. Gerhard Pulverer, Cologne.

Itchô school to be so great that he adopted a new art name, Kôchôrô (literally, 'fragrant butterfly pavilion'), derived from Hanabusa Itchô's names 'Shinkô' and 'Itchô'. He used Kôchôrô both on paintings and prints. His first recorded use of it is on a votive painting (ema)

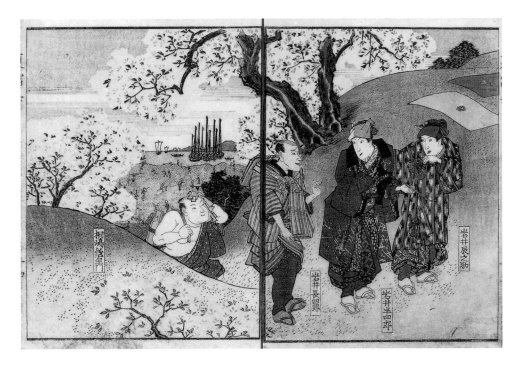

21. Illustration from the two-volume *Fuji in Summer* ('Natsu no Fuji'). The onnagata Iwai Hanshirô V and his son, the onnagata Iwai Kumesaburô II, both in female attire, on an outing with companions to view the cherry blossoms. 1827. Private Collection.

of Ichikawa Danjûrô VII as Arrow-sharpening Gorô, firmly dated as having been presented to the Narita Fudô Temple on New Year's day 1825.[20] His earliest dated use of it in print appears to be in the actor book *Fuji in Summer* (Natsu no Fuji) of 1827. Between 1827 and 1844 he signed the vast majority of his prints and books either 'Gototei Kunisada ga' or 'Kôchôrô Kunisada ga'. There is nothing to distinguish prints signed with the one art name from those signed with the other, either in terms of style or subject matter. What the use of Kôchôrô meant to him remains unclear. All that can be said is that Kunisada wished to proclaim his affiliation with the Hanabusa Itchô school.

Kunisada first made his name as a book illustrator and his activity in this field never slackened. Throughout his career he continued to provide line illustrations for novels. His greatest success in this genre was his collaboration with the author Ryûtei Tanehiko (1783-1842) on *Fake Murasaki and a Rustic Genji* (Nise Murasaki Inaka Genji). This lengthy novel appeared in thirty-six volumes divided into seventy-six parts that were issued at regular intervals between 1829 and 1842. It is reported to have sold an unprecedented 10,000 copies and earned the publisher, author and artist much money. It also gave rise to many sequels and imitations. The writer Bakin commented on it in a letter to a friend written in 1831. He was not impressed by Tanehiko's plot or writing, but conceded that 'girls and boys should enjoy it.' However, he found Kunisada's illustrations to be 'great successes', 'excellent', and concluded that

'Kunisada must be termed the current grand master of *gôkan* illustration.'[21] In the same years that he was engaged in the *Genji* novel, Kunisada also provided illustrations for over 120 other novels.

Kunisada's illustrations for novels were, for the most part, in line only. At the same time he also provided designs for more richly produced books for wealthy connoisseurs. These publications fell into two categories: actor books and erotica (shunga). His first erotic book illustrations were published in 1825, and between that date and 1844 he produced a total of 55 such works.[22] Some, like his four volume *Singing of Love in Four Seasons* (Shiki no nagame) which appeared c.1830, rank among the very finest examples of colour printing to be produced in those years. His most important actor books, which appeared between 1827 and 1835, were also produced to a very high standard. In addition to *Fuji in Summer* (Natsu no Fuji) of 1827, which is printed in full colour and depicts actors in everyday life (fig. 21), there were *Biographies of Eccentric Actors* (Yakusha kijinden) of 1833, which offers finely wrought kabuki scenes (fig. 20) and *A Collection of Thirty-six Flowers of the Stage* (Yakusha sanjû-rokkasen) of 1835, which matches powerful half-length portraits of leading actors with their poems (fig. 19). These last two were printed in a rich range of blacks, greys and blues only. In these three books Kunisada sought once again to emulate the achievements of past masters, for both Shunshô and Toyokuni provided distinguished precedents for them. These titles were the finest actor books to appear in Edo since Toyokuni's publications at the turn of the century.[23]

The divide between Kunisada's actor books and erotica was sometimes blurred. In some of his erotica the male protagonists are actors, Danjûrô VII foremost among them. In the book *A Comparison of Treasures* (Takara awase), which was issued in 1826, Kunisada even provided detailed, free-standing representations of the phalluses of leading actors, including those who specialised in female roles. Kunisada was evidently determined to offer dedicated kabuki fans everything they could possibly want to know about their stage idols.

While Kunisada concentrated on actors and beauties, Edo publishers, in collaboration with other ukiyo-e artists, set about widening the range of subject matter available in prints by promoting landscape and warrior prints. Hokusai (1760-1849) led the way in the field of landscape prints with his 'Thirty-six Views of Mount Fuji' (Fugaku sanjû-rokkei), which was issued between 1830 and 1833. Hiroshige (1797-1858) followed with his first 'Fifty-three Stations of the Tôkaidô Highway' (Tôkaidô gojûsan-tsugi no uchi) in 1833. In the next two years all the leading ukiyo-e artists, including Kunisada, tried their hand at landscapes. Kunisada produced two sets, but he was not comfortable with the genre and quickly abandoned it. Thereafter, when projects required landscapes, he preferred to call upon the services of others. Thus Hokkei (1780-1850) drew the three landscapes included in the book *A Collection of Thirty-six*

20. Timothy Clark, review of *Kunisada's World* in *Andon* 47 (1994), p. 107.

21. From a letter of 6 June 1831 to Tonomura Jôsai, quoted in Markus, *Willow in Autumn*, pp. 156-157.

22. All of his known erotic books are listed in Hayashi Minao, *Edo makura eshi shûsei: Utagawa Kunisada*, Tokyo 1989.

23. For Toyokuni's actor books, see Hillier, *The Japanese Book*, vol. 1, pp. 573 ff.

Flowers of the Stage, while in the 1850s Kunisada relied on Hiroshige and others to design the landscape backgrounds for various sets of half-length and full-figure prints (fig. 22).

The second subject popularised by publishers and artists in these years was warriors. Most ukiyo-e artists had depicted warriors from time to time, but it was only in the late 1820s that Kuniyoshi, whose career had not hitherto been an artistic or financial success, turned to this genre and brought new life to it. His bold and imaginative designs, issued in large sets, proved a great success and his career prospered thereafter.[24] Kunisada had produced the occasional warrior print in the 1810s and 1820s. In response to Kuniyoshi's success he designed some sets of warrior prints in his manner. The results were forced, cluttered designs that lacked Kuniyoshi's inventiveness and eccentricity. The Edo public did not take to Kunisada's warrior prints, so he quickly abandoned this genre, too.

Continuity is an outstanding feature of Kunisada's art from the late 1810s to the early 1840s. It has been argued that in the course of the 1820s Kunisada (and other artists) adopted a more "angular" style of drawing because, as prints "became increasingly a subject of mass production, the style proved very convenient in speeding up the carving of the blocks".[25] Prints had long been mass produced, and the proposition that "angular" designs speeded production is dubious. Some of Kunisada's prints of beauties and actors of the 1820s are drawn with thicker brushstrokes and may be described as chunkier or more angular, but they represent no more than a variant of his established style. In all of his prints, the style of drawing consistently combines subtly modulated brushstrokes, which end in the hooks, turns and points learned in the study of calligraphy, with wire-fine lines. The former were used to describe the outlines of his figures' kimono, the latter were used to draw their faces and hands, and accoutrements such as hairpins.

Kunisada popularised minor innovations, such as the addition of poems to actor portraits, but he did not play a part in any of the major developments in print design that occurred in the late 1820s and early 1830s. His strength as a print designer lay in his ability to capture the drama and excitement of the kabuki stage and to interpret feminine beauty. He was far less successful in other genres. Mindful of this, and of his public, his publishers and his purse, Kunisada did not dissipate his energies by persisting in genres such as landscape and warrior prints where he could not match the achievements of artists such as Hiroshige and Kuniyoshi.

The grand master (1844-1865)

Wide-spread famines triggered serious economic dislocation and social unrest throughout Japan in the latter half of the 1830s. The shogun's officials - riven by internal factions - were very slow in responding with positive policy initiatives. Once they lumbered into action in 1841 they instituted a reform programme that proved more adept at prosecuting those whom they deemed responsible for undermining the established order than addressing the fundamental problems confronting the nation. Among their chief targets in the spring and summer of 1842 were actors, artists, authors and publishers. Kunisada's fellow artist Kuniyoshi was heavily fined for certain of his print and book designs. His friend Ichikawa Danjûrô VII was dragged before magistrates, who found him guilty of 'unbecoming extravagance' and 'insolently and outrageously refusing to know his place'. Danjûrô VII was banned from living within a twenty-five mile radius of Edo and his luxurious residence was demolished. Kunisada's literary collaborator, Ryûtei Tanehiko, died in the wake of hostile interrogations and threats of prosecution. Publication of further instalments of their wildly successful illustrated novel, *Fake Murasaki and a Rustic Genji,* was forbidden, and their publisher was harassed. Although so many near him suffered in this wave of official persecutions, Kunisada himself remained untouched. The author Bakin observed that Kunisada was as culpable as Kuniyoshi, yet escaped punishment. It appears that the authorities sought exemplary persecutions rather than wholesale purges in order to induce compliance among the rest. Their approach proved successful.[26]

Among the proclaimed targets of the reform programme were immorality and extravagance; in the eyes of officials, woodblock prints exemplified both ills. A decree issued in the summer of 1842 to the guild of 'light book' publishers read:

> To make woodblock prints of kabuki actors, courtesans and geisha is detrimental to public morals. Henceforth the publication of new works [of this kind] as well as the sale of previously procured stocks is strictly forbidden. In future you are to select designs that are based on loyalty and filial piety and which serve to educate women and children, and you must insure that they are not luxurious.[27]

Subsequent decrees limited the number of colour blocks that could be employed in the production of prints to eight, restricted polyptychs to a maximum of three sheets, and fixed the price per sheet at 16 *mon*. The exemplary prosecutions of individual artists, publishers and actors coupled with these regulations threatened the very basis of Kunisada's artistic and commercial success, but official decrees could not stifle popular demand for prints, and the industry which supplied that demand was resilient enough to find ways around the restrictions placed upon it. If the government limited prints designs to those 'based on loyalty and filial piety', publishers saw to it that sets of beauties were identified as 'Paragons of Virtue' and sets of actor portraits disguised as 'Loyal Heroes from the Past.' Although the letter of the law remained in force, its intent was quickly subverted.

Publishers and artists weathered the rigours of the new regulations not simply by naming prints in conformity with official requirements but by developing new ways of packaging and marketing them. Previously

24. See B.W. Robinson, *Kuniyoshi: The Warrior Prints.* Oxford 1982, for details of these sets. The largest of his warrior sets of the late 1820s and early 1830s contains seventy-four prints.

25. Jûzô Suzuki and Isaburô Oka, *Masterworks of Ukiyo-e: The Decadents,* translated by John Bester. Tokyo 1969, p. 92.

26. For a fuller account of these persecutions, see Markus, *Willow in Autumn,* pp.183 ff. The indictment against Ichikawa Danjûrô VII is quoted in part in Keyes and Mizushima, *Osaka Prints,* pp. 38-39.

27. Quoted in Akai, 'Common People', p. 183.

most of the prints had been of actors and beauties. They were issued in groups of three, five, seven or ten designs (which could be purchased separately) or as diptychs, triptychs and even pentaptychs. The demand for actor portraits had been self-renewing because they were linked to current productions, while prints of beautiful women were expected to reflect changing fashions and the brief moments of glory of a succession of courtesans. Neither genre could now exploit such topicality and remain within the letter of the law. As noted above, in the late 1820s and the 1830s, the subject matter of commercially issued prints had been extended beyond actors and beautiful women to encompass landscapes and warriors. Although neither of those subjects was topical, publishers had developed a market for 'serialised' prints of landscapes and warriors offered for sale over months and years to form large sets. The size of a set was often determined by popular demand. For example, once all thirty-six designs of Hokusai's 'Thirty-six views of Mount Fuji' had been issued, a further ten designs in identical format were produced. After 1842 publishers continued assiduously to cultivate this market. Toward that end they sometimes numbered the prints in a set and provided title and contents sheets. It is clear that publishers marketed these large sets of prints, which might appear over a period of two or three years, with the intention that they be bound up in albums rather than pasted onto walls and screens. By promoting this new category of consciously 'collectable' prints, publishers were able to minimise the losses they might otherwise have suffered as a result of the restrictions imposed on them in 1842.

Kunisada responded to these changed circumstances by producing a set of beauties that contained an unprecedented 100 prints. These designs passed the censors because each women was linked to a poem from the most popular of all Japanese poetry anthologies, the early thirteenth-century *One Hundred Poems by One Hundred Poets (Hyakunin isshu),* and none were presented as courtesans or geisha. With this set Kunisada and his publisher extended the scope of the large set to encompass beautiful women as well as landscapes and heroes.

At the same time means were devised to package actor portraits into large sets. The need to distance the images of actors from current productions, so as not to fall foul of the censors, was turned to advantage. Actor portraits thus freed from specific performances could be gathered together in retrospective sets of thirty, fifty or more prints, which presented the leading actors of the kabuki stage, both living and dead, in their most memorable roles. Although the actors could not be named, their likenesses were so well known that the print-buying public had no difficulty in identifying them. Almost without exception the actors were shown in half-length in these sets. The earliest of these large retrospective sets of actor prints appeared in 1847. In it Kunisada matched actors' portraits with famous *haikai.* The set's title, *Haika shoga kyôdai,* may be read as 'A Crazy Matching of Poets' Portraits and Poems' but can just as well be read as 'A Crazy Matching of Actors' Portraits and Poems'. The disguise is thin, the purpose of the set obvious, the title purposely provocative, but the censors preferred not to notice.

Kunisada and his publishers exploited a wide range of framing devices and backgrounds for the retrospective sets of actor portraits in order to sustain market interest in them. In 1847-48, for example, he returned to the round mirror format, which he had used with great success in the early 1830s and was to use again in 1859, to produce a vibrant set of portraits (plate 12). In the early 1850s he placed half-length actor portraits against landscapes. The first example of such a linkage was the 1852 set 'From the Fifty-three Stations of the Tôkaidô Highway' *(Tôkaidô gojûsan-tsugi no uchi),* in which Kunisada's bold portraits of actors both living and long dead are placed against landscapes derived from Hiroshige's innovative 1833 landscape set of the same name. The names of the places depicted in the background and the roles in which the actors are shown are inscribed within ornate cartouches, but the actors' names are omitted. The set proved a runaway success. An unprecedented seven thousand copies were sold of some of the designs in it. (Previously, successful actor prints never sold more than three or four thousand copies.) The publisher was so delighted that he held a celebratory banquet.[28] In response to the extraordinary demand for these hybrid prints, publishers eagerly churned out set after set of them. In 1852 alone, they issued in quick succession at least eleven such sets containing a total of nearly 400 prints bearing Kunisada's

22. Ichikawa Omezô I (d.1833) as the warrior monk Benkei in 'Benkei's Daughter' *(Benkei Jôshi),* Act III of *Cherry Tree of the Imperial Palace - Night Attack at Horikawa (Goshô zakura - Horikawa youchi),* before an inset view of Ishiyakushi by Hiroshige. From the set 'The Fifty-three Stations [of the Tôkaidô] from Two Brushes' *(Sô-hitsu gojûsan-tsugi).* The actor is not named. 1855. Private Collection.

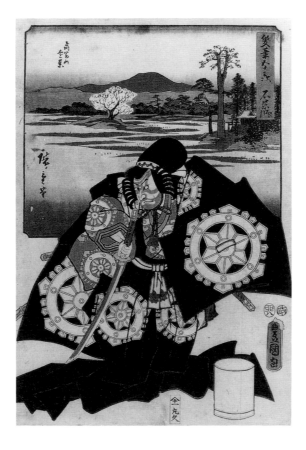

28. Iijima Kyoshin, *Ukiyo-e shi Utagawa retsuden,* p. 137.

signature (plate 13 and fig. 24). Not all of these designs exploited pre-existing landscapes. In many Kunisada relied upon pupils who worked in Hiroshige's manner to produce suitable backgrounds.

The success of these prints led the artists and their publishers to explore the commercial potential of other combinations of Kunisada figures with Hiroshige landscapes. One of the freshest and most striking of their collaborative efforts was 'The Fifty-three Stations [of the Tôkaidô] from Two Brushes' *(Sô-hitsu gojûsan-tsugi)*, which was issued between 1854 and 1857. This set contains fifty-five designs in which full-figure actors stand before square inset landscapes (fig. 22). The artists also collaborated on many triptychs in which groups of beautiful women by Kunisada were presented against Hiroshige's landscapes.

Half-length actor portraits remained a very important feature of Kunisada's output to the end of his life even though the half-length against a landscape ceased to dominate his output after 1856. In the late 1850s and early 1860s, in addition to reviving the mirror format for a third time, he designed sets in which half-length figures were placed against a deeply coloured ground scattered with various emblems and cartouches, or shown against a white ground decorated with delicately printed nature studies by other artists, or surrounded by lengthy texts.

By 1850 the enforcement of the restrictive regulations of 1842 had become so lax that designs illustrating current kabuki productions were being passed by the censors. Only the naming of actors was still prohibited, and would remain so for another seven or eight years. Thus, at the time that Kunisada was engaged in the production of large, retrospective sets of half-length portraits, he was also providing the usual range of full-figure and half-length actor designs tied to specific performances. In addition, prints celebrating the exploits of the 'Rustic Genji' came to be much in demand. The latter were based on the imagery that Kunisada had created in his illustrations for Tanehiko's serial novel, *Fake Murasaki and a Rustic Genji* (1829-1842). This novel, its sequels, theatrical adaptations and imitations were so popular that publishers were able to develop a market for colour prints illustrating key episodes in it. Kunisada's output dominated the print market, but Kuniyoshi and Hiroshige remained active players in it in their own right. The Edo print industry not only survived the prosecutions and draconian reforms of 1842, but flourished as never before in the 1850s.

At New Year 1844, less than two years after the regulations aimed at restricting print production had been promulgated, Kunisada announced his assumption of the name Toyokuni. Toyoshige, who in Kunisada's view had usurped the use of that name in 1825, had died in 1835. It is not clear why Kunisada did not take his teacher's name immediately after Toyoshige's death. There may have been personal reasons, such as the opposition of a determined widow. Alternatively, the

economic and social unrest of the late 1830s, followed by the disruption and uncertainty caused by the reforms of 1842, may have convinced Kunisada that he ought to wait for a more propitious time. When he finally assumed his teacher's name, Kunisada pointedly ignored Toyoshige's use of it, proclaiming himself Toyokuni II. He did so by means of a signature that read, 'Kunisada changing to Toyokuni II' *(Kunisada aratame ni-dai Toyokuni)*. He signed his work Toyokuni for the rest of his life. (Today Toyoshige is referred to as Toyokuni II, and Kunisada as Toyokuni III. In this study Kunisada is at all times referred to as Kunisada.)

In 1847, in his sixtieth year, Kunisada shaved his head and took lay vows. This move, to ensure his spiritual well-being, did not impinge upon his professional life. At this time he also arranged for the marriage of his eldest daughter, Ôsuzu, to his pupil Baidô Kunimasa (1823-80) and in 1851 bestowed the name Kunisada II on him. It is an indication of Kunisada's financial success that in the following year he was able to give his house and studio in Kameido to his son-in-law, when he bought himself a grand new home in nearby Yanagishima.

Kunisada and his contemporaries recognised a qualitative difference between his early and middle period prints, and his late period prints which he signed 'Toyokuni'. The latter were described as being in the 'modern style' *(imayô)* and very much admired for it. In general Kunisada's print designs of the 1810s and 1820s were not much more complex than those of Utamaro or Toyokuni in the 1790s and 1800s. His work tended to greater complexity in the 1830s and by the late 1840s more elaborate designs had become the norm. This was in part the result of employing new, more opaque pigments, which saturated the paper in a way that the pigments used previously had not. The unprinted or lightly tinted backgrounds of the earlier prints gave way to landscape or deeply coloured backgrounds. So as not to lose those elements that appeared on all commercial prints - the artist's signature, censor's seal(s), the block-cutter's mark, publisher's name and/or mark, set title and print title - against these richer backgrounds, Kunisada set them off in boxes and cartouches. Kunisada handled the resultant complexity with great assurance, which guaranteed that all the information was well ordered and easily read (figs. 23 and 24).

Kunisada's prints in the 'modern style' are distinguished by the technical brilliance of their printing, their deep, saturated colours, their complex designs and their very high level of finish. The mastery of Edo block-cutters and printers had never been greater than it was in the 1850s and 1860s, but the technical virtuosity evident in these prints does not interfere with our appreciation of Kunisada's art. On the contrary, it heightens it, since he exploited the capabilities of his block-cutters and printers to brilliant effect.

Between 1844 and his death early in 1865, Kunisada was responsible for a prodigious outpouring not only of prints but also of illustrated books. In this period there

23. Ichikawa Ebizô V (formerly Danjûrô VII) as Umeômaru in a production of *Sugawara and the Secrets of Calligraphy (Sugawara denju tenarai kagami)* at the Nakamura Theatre in late 1835. Private Collection.

24. Ichikawa Ômezô I (d. 1833) as Umeômaru shown before Plum Tree village between Minakuchi and Ishibe on the Tôkaidô. From the set 'Between the Fifty-three Stations of the Tôkaidô' *(Tôkaidô gojûsan-tsugi no uchi . . . kan)*. The actor is not named. 1852. Private Collection.

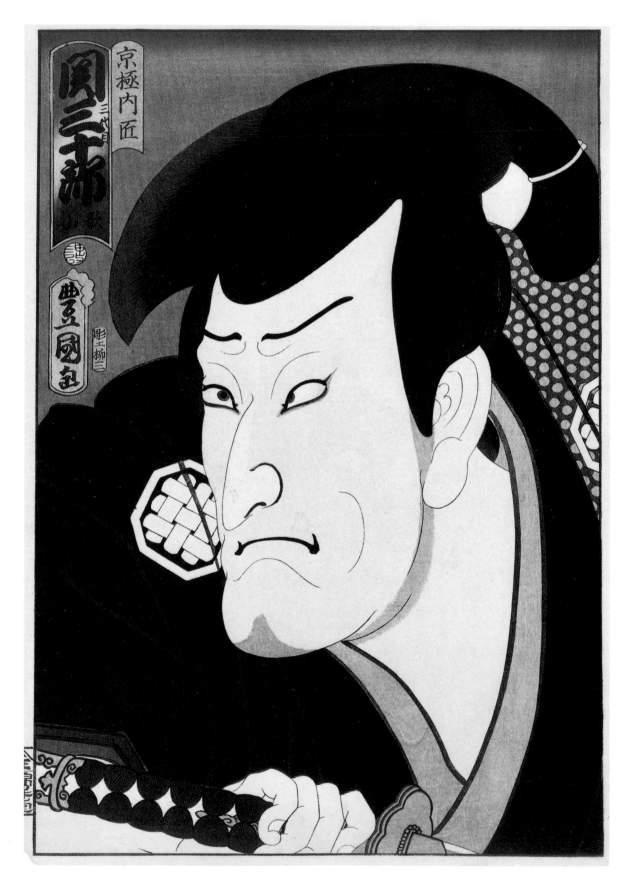

25. Seki Sanjûrô III (1805-1870) as
the villainous fencing master
Kyôgoku Takumi in *Hikosan
gogen chikai no sukedachi*. From
the untitled set known as
'Famous Kabuki Actors Past and
Present' *(Konjaku kabuki meiyû)*.
1860. Robert Schaap,
The Netherlands.

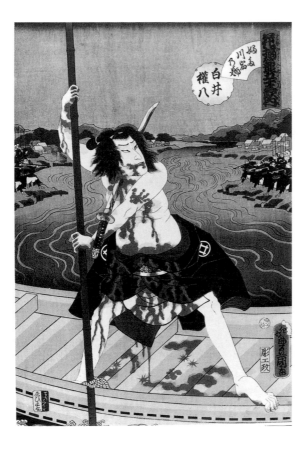

26. Ichikawa Ichizô III as the popular hero (otokodate) Shirai Gompachi committing suicide when trapped by police. Such violence and sensationalism are rare in Kunisada's prints. 1860. Arendie and Henk Herwig. The Netherlands.

were dozens of print publishers active in Edo and Kunisada provided designs for most, if not all, of them. Certain publishers issued large numbers of his prints and groups of publishers cooperated on some of the larger sets, but at no point in his career did Kunisada ever work exclusively for a single publisher or group of publishers. It is not possible to determine the exact nature of his relationship with his publishers. Did he follow their lead, responding obediently to their requests, or did he push them to experiment with new formats? How much did he receive for designs? What control did he retain over the finished product? His experience of the print business extended over sixty years. His print designs set new sales records, his book illustrations were always popular. In the closing decades of his life, he must have been a formidable figure in the publishing world, yet we know nothing for certain about his role in it.

Kunisada met the enormous demand for his print designs and book illustrations in his later years through reliance on a well-organized studio that employed some sixty students and assistants. He supervised the assembly of new designs from a wide range of sources, but left their elaboration and realisation to his pupils. So firmly had he established his house style that the consistency and coherence of the finished product was guaranteed.

The most important source of inspiration he and his students drew upon was his own earlier work. In addition to reworking his earlier print designs, they also mined the rich store of book illustrations he had produced over the years for ideas that could be worked

up into triptychs. They also borrowed from other artists. Such borrowing was not infrequent among Japanese artists, nor was it particularly frowned upon. From the very beginning of his career Kunisada had never hesitated to rework the compositions of others, particularly his teacher Toyokuni. When he borrowed from him in the 1820s and 1830s, he did little more than transcribe his teacher's designs. In the last fifteen years of his life he reworked those borrowings in his 'modern style.'[29] The clarity and strength of his style and the skill and professionalism with which he ran his studio, combined with the brilliant technique of the Edo block-cutters and printers, assured the transformation of his designs, whatever their source, into exciting new prints.

A certain degree of repetition was inevitable as successful formulae were used and reused. Yet, given the vast number of designs in similar format that Kunisada's studio produced, it is remarkable how powerful and exciting each individual print can be. This is particularly the case with the many half-length actor portraits. The prints most likely to disappoint in this period are triptychs depicting actors in scenes from current kabuki performances. In these designs the stiffly rendered figures of the actors are set against detailed depictions of the stage sets. No doubt these prints provide accurate records of specific performances, but they are otherwise undistinguished. Work on them must have ranked low in the hierarchy of studio responsibilities.

In a significant proportion of his most impressive late designs Kunisada distances himself from a particular performance of a role and seeks instead to capture the 'legendary' quality that inspired all of a great actor's performances in that role. These designs glow with a particular intensity, and Kunisada's input is likely to have been more direct here than in the work-a-day prints recording current performances. Kunisada's interest in capturing 'legendary' performances may reflect a move in the kabuki theatre at that time toward the standardisation of the performance of great roles.[30]

A recently published group of seven letters written by Kunisada in 1863 casts new light on his character and his approach to his trade. Among the topics he discusses in them is his view of the differences between the portrayal of actors by artists of his own school and the portrayal of actors by artists active in Osaka. He is scathing in his condemnation of the latter. He claims that the portraits in Osaka prints hardly resemble their subjects, that the faces show no intelligence or spirit, and that they are weak and boring. Elsewhere in these letters he discusses the way in which he intends to depict certain actors in the set of 'large-head' prints (ôkubi-e) on which he was then working. He comments with great precision on the facial characteristics of actors, even of those long dead. These letters also reveal something of his attention to the technical side of print production, for in one he expresses his annoyance that a block cutter who was too young and therefore lacking in understanding had been allowed to cut the keyblock for one of his designs. These letters confirm the impression

29. For examples of such borrowings and transformations see Ellis Tinios, 'Kunisada and the Last Flowering of Ukiyo-e', figs. 197 and 198, and 199 and 200.

30. This paragraph draws upon observations made by Paul Griffith in conversation and correspondence.

gained from the study of his prints that Kunisada not only knew exactly what he wanted to achieve in his prints but that he was able to convey it to his students and his publishers.[31]

Kunisada rounded off his career as a designer of actor portraits with the unnamed set of prints commonly referred to as 'Famous Kabuki Actors Past and Present' (Konjaku kabuki meiyû) (plate 16 and figs. 25 and 27). He intended to provide a survey of the great actors of the past hundred years in this set, which was the only one he ever produced in 'large-head' (ôkubi-e) format. The format had been exploited to great effect in the 1790s, but was then banned by the authorities in 1800. This was its first revival. The letters discussed above were addressed to an Edo iron and copper merchant named Mitani, who appears to have subsidised the set and may have been responsible for the choice of format. From the letters it appears that Mitani took a great interest in the way Kunisada intended to depict the actors chosen for inclusion in it.[32] Although Kunisada began work on the set in 1860 and was assisted by Yoshitora (c.1830-c.1887), no more than seventy prints had been issued at the time of his death in 1865. Kunisada's relatively slow rate of production of designs for this set does not indicate a slackening in the output of his studio. Many other sets of quality bearing his signature appeared concurrently with these prints. 'Famous Kabuki Actors Past and Present' was a long-term project cut short by Kunisada's death. Age had not diminished his powers. There is nothing retrospective or autumnal about the set. Rather than providing a summing up of all that had gone before, it suggests exciting new paths that Kunisada's art might have followed. He produced many of his boldest and most immediate actor portraits for this set. The force of his designs, which strain the confines of the sheet, is perfectly matched by the depth and strength of the pigments, and the outstanding quality of the finish achieved by the printers. The set formed a fitting crown to his career.

Kunisada, Hiroshige and Kuniyoshi dominated print production in the 1840s and 1850s, providing the public, both separately and in collaborative efforts, with the actor, warrior and landscape prints it craved. Hiroshige, still in full possession of his powers, died in a cholera epidemic in 1858. Because of ill health Kuniyoshi's output in the five years before his death in 1861 'was small and, for the most part, undistinguished.'[33] Kunisada, his creativity undiminished, thus ended his life acclaimed as the greatest print artist of the age. In the last three years of his life he took to incorporating his age into his signature. There is something exultant about these signatures that proclaim prints as being 'from the brush of the seventy-such-year-old Toyokuni.' According to Japanese reckoning, he lived to his seventy-ninth year. He was in good health to the end, his death after a short illness coming as a surprise to his family and friends.

The last decade of Kunisada's life was a time of great upheaval in Japan. The arrival of the Americans in 1854 with their demands that Japan open its ports to foreign trade shook the political establishment to its foundations. The shogun had no choice but to concede to those demands, but in so doing he seriously compromised his legitimacy as defender of the realm. Activists openly challenged his right to rule, demanding the restoration of imperial authority and the expulsion of all foreigners. The late 1850s and 1860s witnessed growing political violence - purges, assassinations, executions, skirmishes with foreign forces, rebellions and uprisings - that would culminate in 1868 in the collapse of the shogunate and the establishment of a new, imperial regime. None of this impinged directly upon Kunisada's art. Its focus and concerns remained unchanged.

Kunisada was described by a contemporary and close collaborator as possessing 'a gentle, unassuming nature.'[34] He associated with the leading authors, poets and actors of his day, he worked diligently and never contracted debts or fell foul of the authorities. His was an uneventful life, devoted to his craft. This devotion led to the production of many thousands of colour woodblock prints and tens of thousands of book illustrations bearing his signature. In them he never failed to display his confident mastery of design and the complete professionalism of his approach. He knew his strengths, knew what his public wanted and acted on that knowledge. Through more than five decades he was never out of fashion, always a commercial success. He was an exponent of a living art form who spoke directly and effectively to his contemporaries.

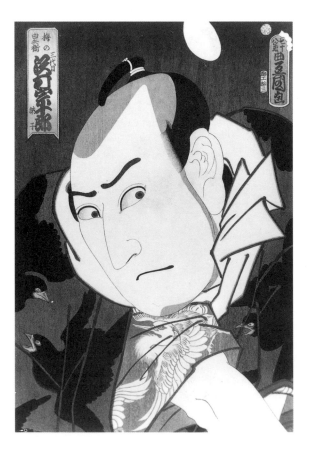

27. Sawamura Sôjûrô III (1753-1801) as Ume no Yoshibei in The Character of a Geisha in the Sumida Spring (Sumida haru geisha katagi) as performed in 1796. From the untitled set known as 'Famous Kabuki Actors Past and Present' (Konjaku kabuki meiyu). 1863. Gerhard Pulverer, Cologne.

31. Ôkubô Jun'ichi, 'Letters', pp. 25-39.

32. Ibid.

33. B.W. Robinson, Kuniyoshi. London 1961, p. 23.

34. Shikitei Sanba quoted in Markus, Willow in Autumn, p. 80.

Epilogue

Kunisada was first brought to the attention of a wide audience of Western collectors and connoisseurs of Japanese prints with these words:

> This very undistinguished artist was one of the most prolific of the ukiyo-e school. All that meaningless complexity of design, coarseness of colour and carelessness of printing which we associate with the final ruin of the art of colour-prints finds full expression with him.[1]

This view of Kunisada arose in part from the fact that the first Western students of Japanese prints came to them with all the critical baggage of nineteenth-century art history, which defined aesthetic ideals against which all art had to be judged and as a corollary insisted upon an inevitable falling away from those ideals.[2] Thus to an early critic like Ernest Fenollosa, Torii Kiyonaga (1752-1815) represented an 'absolute aesthetic height' in the history of Japanese woodblock prints, 'even worthy of coming into comparison with ... Raphael'.[3] From such a pinnacle, decline was sure to be swift and certain to lead to 'final ruin'.[4]

This study should make clear that Kunisada's prints deserve better than to be described as offering nothing but 'meaningless complexity of design, coarseness of colour and carelessness of printing'. Carelessness of printing is rarely to be encountered in Kunisada's prints of any period. Even mediocre designs were produced to an exacting standard. Technically, the prints of the 1850s are at least as finely produced as those of the 1780's, the so-called 'Golden Age' of print production.

To define colours as 'coarse' is to engage in a subjective exercise. Bright colours in startling combinations formed an essential feature of all Edo-period woodblock prints. The instability of many of the bright pigments employed in the eighteenth and early nineteenth centuries has hidden from us the 'garishness' of the prints of Kunisada's predecessors. In the course of his long career Kunisada employed the full range of colours and tones available to him, from delicately graded tints to deeply saturated primary colours. In all periods he employed the colours at his disposal with total confidence and to great effect. Kunisada was as assured in his handling of colour as any of his predecessors.

In general Kunisada's print designs of the 1810s and 1820s were no more elaborate than those of Utamaro or Toyokuni in the 1790s and 1800s, but they displayed much greater complexity in the last decades of his career. As already explained, this was hardly 'meaningless'. One scholar has recently preferred to refer to it as 'dazzling complexity of design' masterfully handled by Kunisada.[5] Such an assessment is far nearer the mark.

Another school of criticism explains the 'inadequacies' of Kunisada's prints, not as the products of the inevitable decay of an art form, but as manifestations of the blighted times in which the artist lived and worked. Adherents of this school observe in Kunisada's art 'the stunted and misshapen quality of the Edo-period merchant-townsman culture as it withered under feudal pressure and failed to achieve a healthy development'.[6] It is unwarranted to assert that the quality of his art was determined by the political and economic 'health' of the age in which he lived. Although the closing decades of the Edo period were a time of great tension - the economy was failing, social disorder was rife, the old political order was slowly unravelling - those years also saw 'one of Japan's great flowerings' of literature, art and thought.[7] Kunisada's creative career spanned more than half a century. In all periods he designed remarkable as well as ordinary prints. His prints deserve to be viewed without prejudice within their historical and cultural context.

28 Kunichika (1835-1900). A single-sheet memorial portrait of Kunisada seated at a writing desk with Ichikawa Danjûrô VII (d. 1859) looking down on him. 1865. Trustees of the British Museum.

1. Arthur Davison Ficke, *Chats on Japanese Prints.* London 1915; reprinted Tokyo 1958, pp. 351-2.

2. This discussion draws upon ideas set out by Timothy Clark in 'Kunisada and Decadence: the Critical Reception of Nineteenth-century Japanese Figure Prints in the West' in *Modern Japanese Art and the West: International Symposium.* Tokyo 1992, pp. 89-100.

3. Ernest Fenollosa, *Epochs of Chinese and Japanese Art.* New York 1912; reprinted New York 1963, vol. 2, p. 195.

4. Avant-garde artists of the period did not share this view, but their responses are beyond the scope of this study.

5. Clark, 'Kunisada and Decadence', p. 97.

6. Seiichirô Takahashi, *Traditional Woodblock Prints.* Tokyo 1964, first English edition, Tokyo 1972, p. 130.

7. Harold Bolitho, 'The Tempô Crisis' in *The Cambridge History of Japan, Vol. 5, The Nineteenth Century.* Cambridge 1989, pp. 116-17.

Suggestions for further reading

The last part of Conrad Totman's *Early Modern Japan* (Berkeley 1993) offers an illuminating account of the political, economic, social and cultural history of the period in which Kunisada lived and worked. *Tokugawa Japan: The Social and Economic Antecedents of Modern Japan* (Tokyo 1990), edited by Chie Nakane and Shinzaburô Ôshi, translation edited by Conrad Totman, contains informative articles on publishing, printing, kabuki, and popular culture by Japanese scholars.

The best short introduction to the kabuki theatre is Matsukatsu Gunji's *The Kabuki Guide* (Tokyo 1987). For greater emphasis on plays in performance see Ronald Cavaye's *Kabuki: A Pocket Guide* (Tokyo 1993). For summaries of the plots of popular plays consult *The Kabuki Handbook* (Tokyo 1956) compiled by Aubrey and Giovanna Halford. Earle Ernst in *The Kabuki Theatre* (Oxford 1956, reprinted Honolulu 1974) provides a dense account of the theory and practice of kabuki. An excellent introduction to kabuki plays as literature will be found in Donald Keene's *World Within Walls: Japanese Literature of the Pre-modern Era, 1600-1867* (Tokyo 1978).

Richard Illing's *The Art of Japanese Prints* (London 1980) provides a general introduction to Japanese woodblock prints. *Ukiyo-e to Shin hanga,* edited by Amy Newland and Chris Uhlenbeck (Leicester 1990), contains articles on print production and the evolution of the art form. Sarah E. Thompson and H.D. Harootunian in *Undercurrents of the Floating World: Censorship and Japanese Prints* (New York 1991) explore cultural politics in the Edo period and the politics of woodblock prints. *The Floating World Revisited* (Portland, Oregon 1993), edited by Donald Jenkins, contains five scholarly and informative essays on key aspects of the ukiyo or floating world. The only systematic treatment of nineteenth-century books devoted to kabuki will be found in Jack Hillier's monumental *The Art of the Japanese Book* (London 1988) (Volume I,

Chapter 41, 'The Later Kabuki Stage in Edo').

Kunisada is one of the three artists dealt with by Jûzô Suzuki and Isaburô Oka in *Masterworks of Ukiyo-e: 'The Decadents'* (Tokyo 1969). This book contains a short account of Kunisada's career and reproduces thirty-five of his prints, but all were issued before 1844 and only two of them depict actors (all the rest depict beautiful women). The profusely illustrated exhibition catalogue *Kunisada's World* (New York 1993), compiled and written by Sebastian Izzard with additional essays by J. Thomas Rimer and John T. Carpenter, covers Kunisada's entire career and deals with his work in all genres. Shigeru Shindô's *Kunisada's Actor Portraits* (Tokyo 1993) surveys the full range of Kunisada's commercial actor prints. All the print captions have been translated into English but not the short biography of the artist.